IMAGES
of America

CONCORD

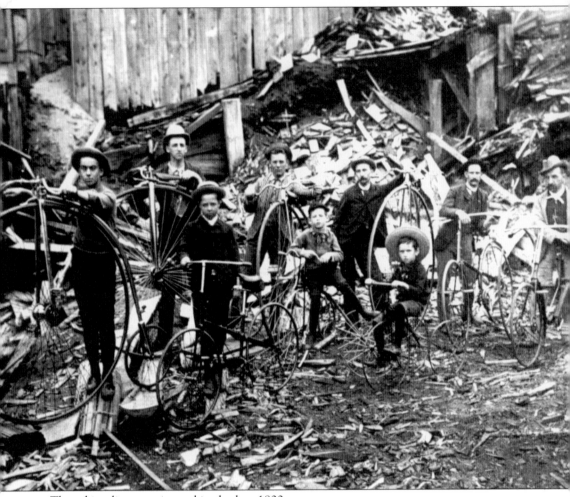

These bicyclists are pictured in the late 1800s.

IMAGES
of America

CONCORD

Concord Historical Society

ARCADIA

First printed in 2003.

Published by Arcadia Publishing,
an imprint of Tempus Publishing Inc.
2A Cumberland Street
Charleston, SC 29401

Printed in Great Britain.

Library of Congress Catalog Card Number: 2003105604

For all general information, contact Arcadia Publishing:
Telephone 843-853-2070
Fax 843-853-0044
E-mail sales@arcadiapublishing.com

For customer service and orders:
Toll-free 1-888-313-2665

Visit us on the Internet at www.arcadiapublishing.com.

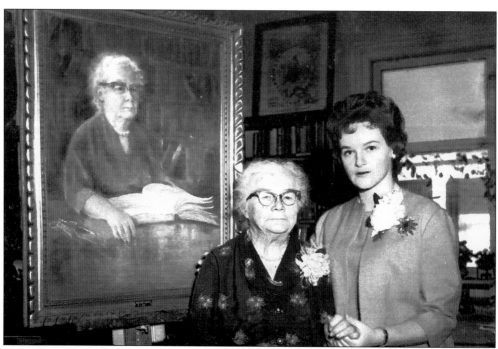

"Miss Lucy" Bensley is pictured at her retirement party with Marilyn Seeland, the artist who painted her picture. Miss Lucy served the community for almost 60 years.

CONTENTS

*Dedicated to the memory of former members of the
Concord Historical Society, Lillian Domes Geiger and
Lucy Bensley. Without their preservation of historical
articles and pictures and their profound memories and notes
about bygone days, this book might never have been possible.*

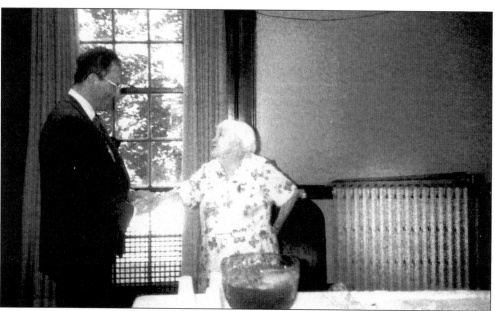

Lillian Geiger receives congratulations at her retirement party from Dr. William Seiner, the
Erie County historian and head of the Buffalo Historical Society.

INTRODUCTION

This book includes pictures and pieces of information to make the reader think, remember, and appreciate what the early settlers went through. Neither do we take anything from the people who followed them, right up to today. Every generation and every person has contributed to the history of Concord in some way.

We have prepared this book with the information available. If there are errors, we are sorry, but dates can become jumbled and memories dim. It is important to give a window to the past and also fun to recognize an old landmark or a familiar face. This book is for enjoyment. It is important to preserve the information we have. Thank you for your interest.

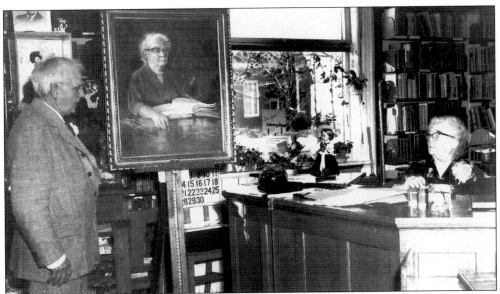

"Miss Lucy" Bensley is shown with her portrait and Grandpa Olmstead, a Springville artist. Miss Lucy had an extensive doll collection, which she left to the historical society. Her collection, along with that of Anna Brooks, is on display at the Warner Museum.

ACKNOWLEDGMENTS

We are not thanking people specifically because we are afraid we might miss someone who helped us in any way with this book. We wish to thank everyone for their pictures, their input, and their time. This book was made possible only because of *you*! Thank you, thank you!

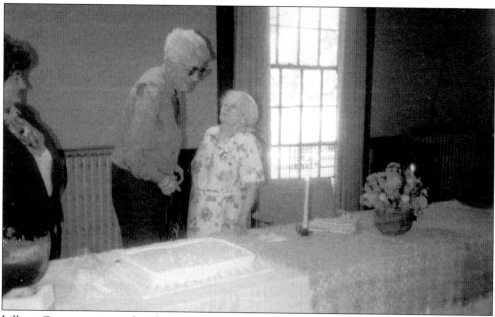

Lillian Geiger is pictured at her retirement party with her dear friend and fellow historian Julia Reinstein.

One

SPRINGVILLE

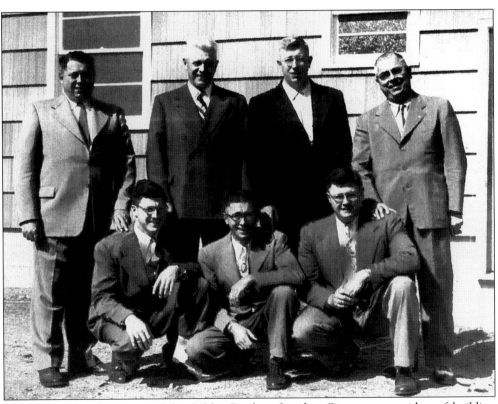

These are the Salzler boys of the Salzler Brothers Lumber Company, providers of building supplies. Started by their father, the business at one time had two locations: the mill on Mill Street and the store on West Main Street. Salzler Brothers was well known for its quality merchandise, friendliness, and integrity for more than 50 years. From left to right are the following: (front row) Gordon, Francis, and Maynard; (back row) Gerald, William, Lawrence, and Charles. This picture was taken in 1956.

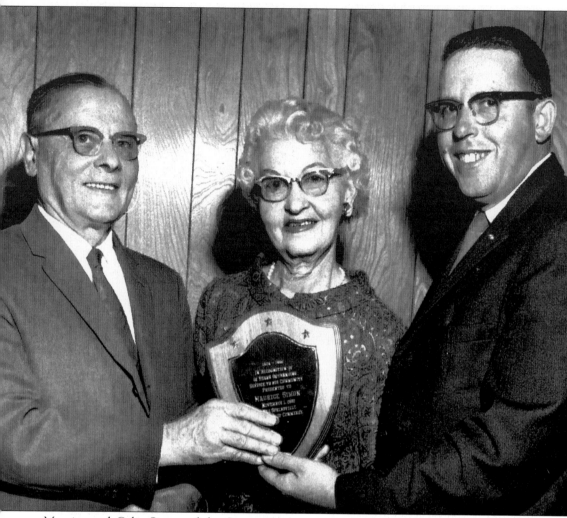

Maurice and Celia Simon of the Simon Brothers store are shown receiving a plaque from Richard Fancher of the chamber of commerce. The Simons were honored for being merchants in Springville for 50 years and for their many contributions to the town.

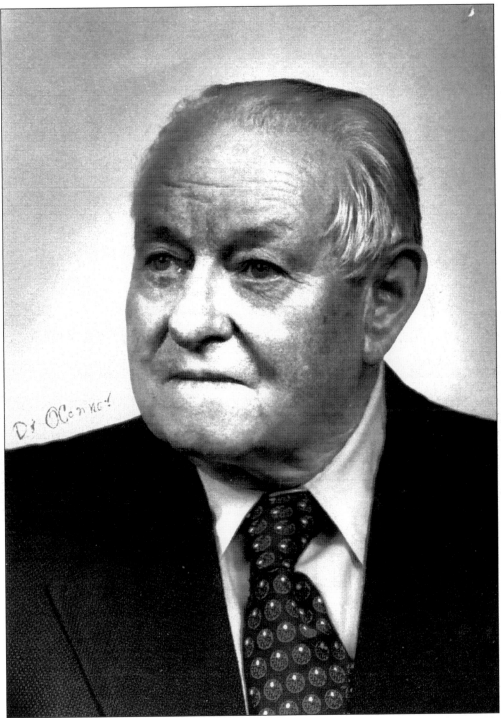

Dr. Maurice O'Connor was a cheerful, robust man who really relished small-town living. He had a host of patients and friends, both young and old. Florence Weismantel worked for O'Connor for years and was also loved by all. The doctor's home on East Avenue was known for a radiant look provided by his rhododendrons every spring.

Grace Salzer Gentner retired as town clerk on January 23, 1982, after 23 years of dedicated service.

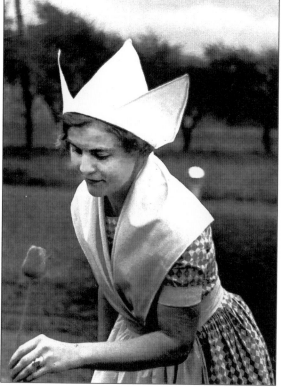

Lillian Domes Geiger is dressed in her Dutch girl outfit for the Holland, New York Tulip Festival. She is remembered for getting all the present historical markers for the town. She had a phenomenal memory and quoted facts and dates with ease. She also had a personal collection of historical treasures.

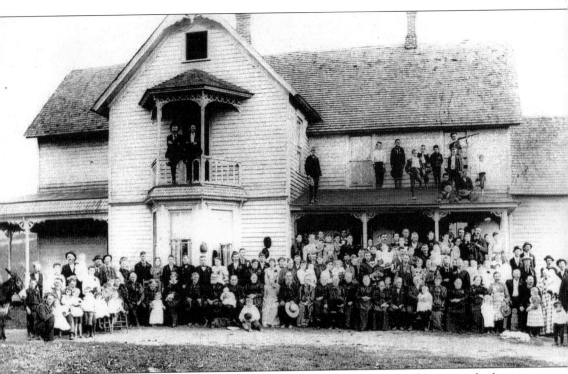

This is a Goodemote reunion held in the early 1900s. Standing on the roof is a man who lost a leg in a railroad accident.

This early view shows a milkman making his rounds.

Posing in Fiddler's Green Park are some of the people who attended the unveiling of the "first settler" sign. Lillian Geiger, the local historian, is on the right.

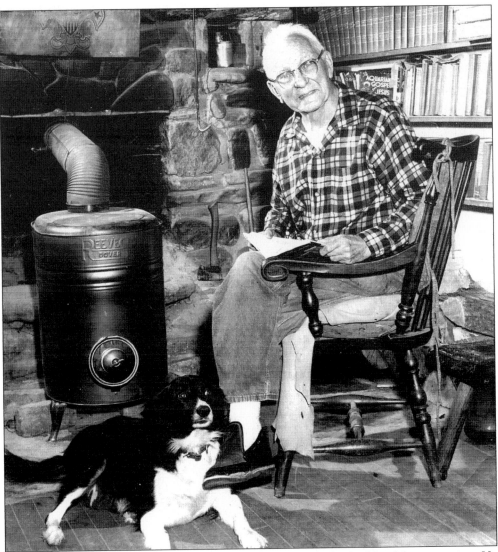

This is Conrad Meinecki, a former Boy Scout official who devoted his life to scouting. He passed away in 1971 at the age of 87. He lived the good life, which he taught to many boys.

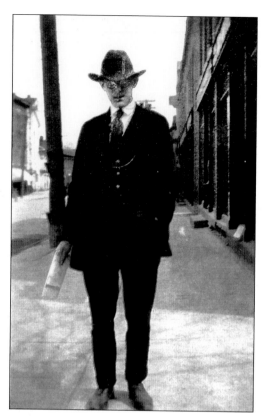

E. Richard Lowe (pictured here) and his son William were the last of the Lowes to own the *Springville Journal*. The journal was sold in 1986 to H & K Publications. William Lowe's great-uncle Walter W. Blakely owned it from 1867 to 1889. Various people owned the journal after Blakely, but the Lowes continued to be involved. In 1967, the publication's centennial year was celebrated. The historical society is extremely fortunate to have copies of the journal dating from 1867.

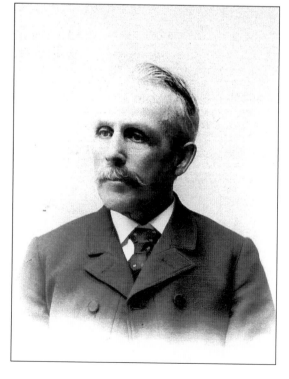

This is James Blake, father of William Blake. William was listed in the 1912 *Springville Directory* as a barber. William and his wife, Carrie, had one daughter, Itasca. Itasca married Thomas Kenney, who served as village clerk for Springville for nearly 30 years.

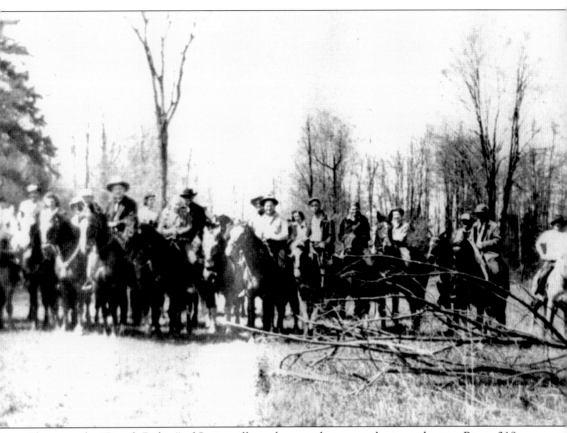

These are the "Rough Riders" of Springville at the spot that was to become the new Route 219. As well as riding for the sheer joy of riding and the friendship involved, they also helped farmers round up cattle. Frances "Honey" Watson Potter and husband Bill Potter met while part of the group. They recently celebrated 57 years of marriage.

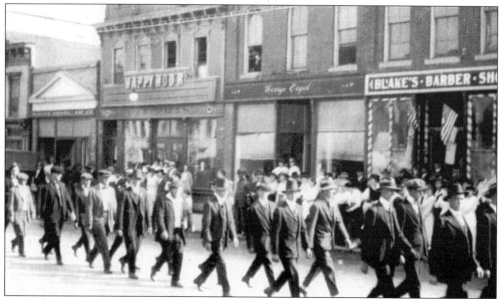

This photograph shows a parade down Main Street before these "drafted boys" went off to World War I.

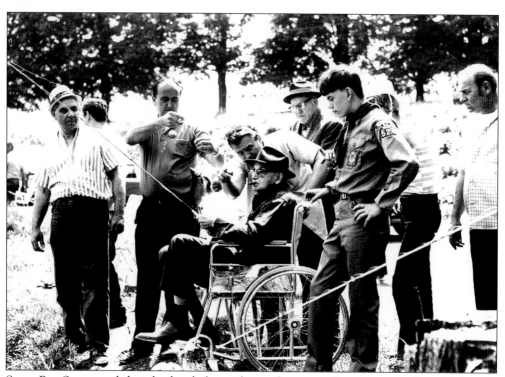

Some Boy Scouts and their leaders help residents of a nursing home enjoy a day of fishing at the trout pond on North Buffalo Street.

Pictured at a luncheon are some retired Griffith Institute teachers who were part of a group that got together once a month for years. From left to right are Harriet Davis, Eleanor Gale, Loretta Hannon (who always wore a hat), Gladys Lincoln, and Eleanor Barie.

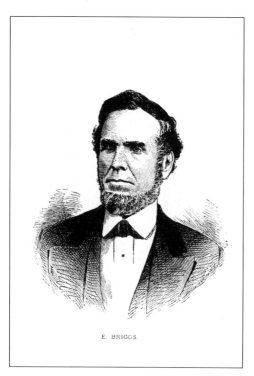

E. BRIGGS.

Eramus Briggs was born on August 31, 1818, on Townsend Hill. He was a teacher, superintendent of schools, town supervisor, justice of the peace, writer, and historian. His legacy was the 1883 book *History of the Original Town of Concord*, which contains biographies of many of the first settlers of Concord and has been used by many for genealogical research. The book also contains valuable information about the town not available anywhere else. The reprint has been enhanced by an index of every name in the book. Briggs's birthday was recently celebrated, and his distant relatives attended and joined the historical society.

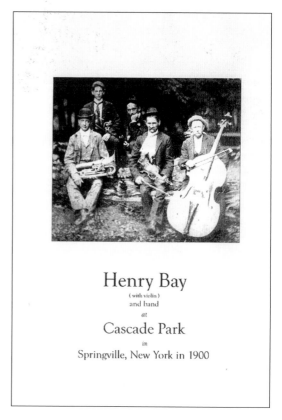

Henry Bay
(with violin)
and band
at
Cascade Park
in
Springville, New York in 1900

Many people from the city came by train to Cascade Park. Picnic grounds were available, and the beauty of the park was theirs to enjoy. Henry Bay and his band played there.

Ed Kern (right) was born in 1887. This picture was taken in front of the Concord House in 1927.

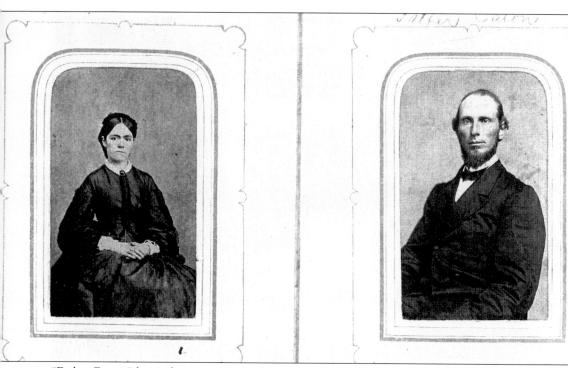

"Father Eaton," better known as Luzerne Eaton, was a direct descendant of Rufus Eaton, who arrived in Concord shortly after 1807. These pictures of Luzerne and his wife, "Mother Eaton," are probably some of the earliest pictures of settlers in Concord.

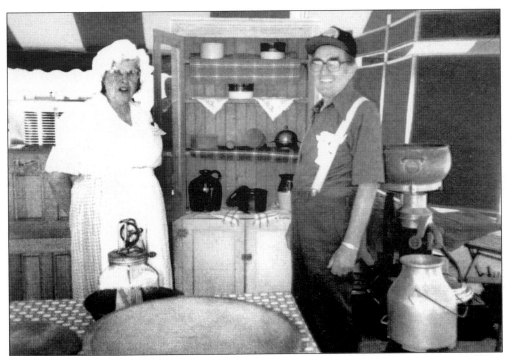

At the Dairy Festival in 1991, Ruth and Joe Maul demonstrate early butter making, complete with all the old artifacts.

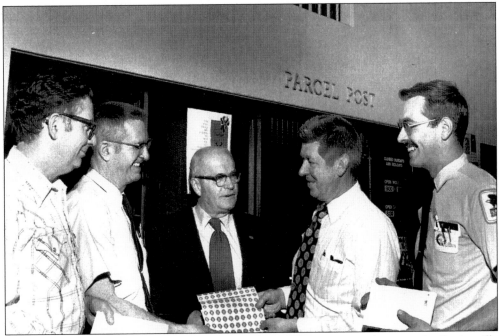

There was no such thing as "snail mail" when these fellows were in charge at the Springville post office. The post office, built by the Work Projects Administration during the Great Depression, is now on the National Register of Historic Places. From left to right are Wesley Chandler, Homer DeWitt, Donald Aldrow, Stanley Darzewski, and Joel Maul.

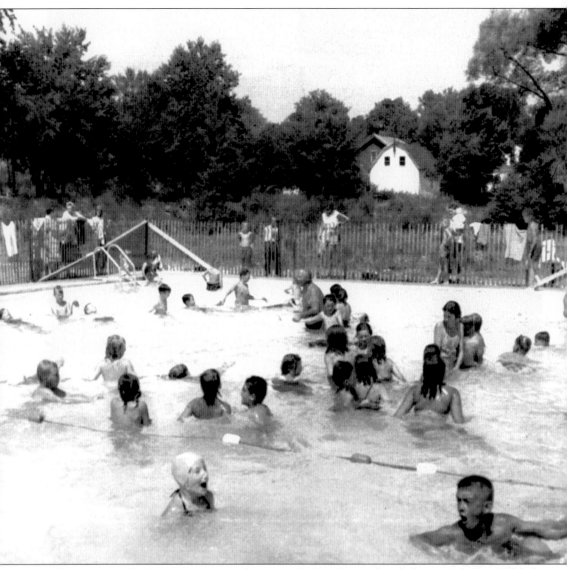

This is Springville Youth Incorporated in its early days. It was founded in 1943 by Leo Schlade and George Whitehead. The pool is located on South Buffalo Street, home of the original Springville Water Works. Springville Youth Incorporated now has year-round activities, including swimming, skiing, snowboarding, ice-skating, and many other good-weather sports and programs. The community is proud of all those who have donated their time and money for the youth of the village.

Jack Yellen was born in Buffalo. He attended high school there and went on to the University of Michigan. He became a newspaper reporter and then joined the army during World War I. In 1929, he came to Springville and bought a farm at Mortons Corners, where he wrote music. Over four decades, he provided the words for more than 130 songs, among them "Happy Days Are Here Again," Franklin Delano Roosevelt's well-known campaign song. He died in his Springville home on April 17, 1991, at the age of 98.

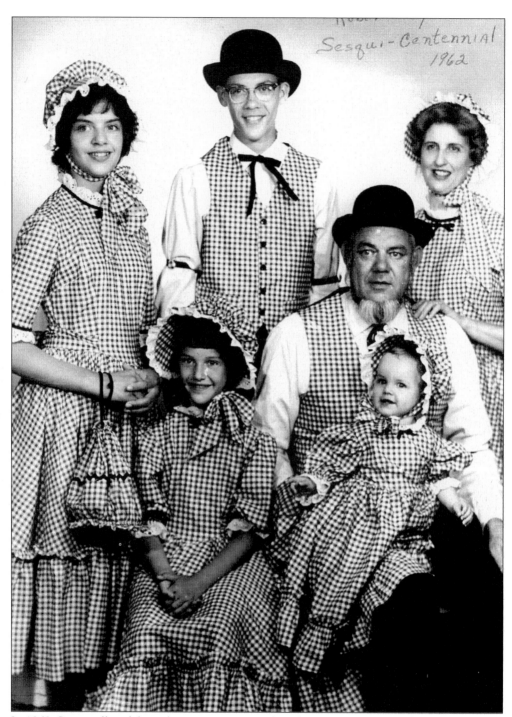

In 1962, Springville celebrated its sesquicentennial, and everyone took part. This is the Robert Ingerson family all decked out in matching outfits. Robert Ingerson was a former coach for Griffith Institute. Ingerson Drive, which leads to the back of the school and the football field, was named for him in 1990. Ingerson's wife, the former Marie Mahl, was also a former teacher, and she made their outfits.

According to Bob Botsford, these three gentlemen were in a play. Both Gordon Rouse (center) and Vernon Botsford (right) worked at the Springville post office. The person to the left is unidentified.

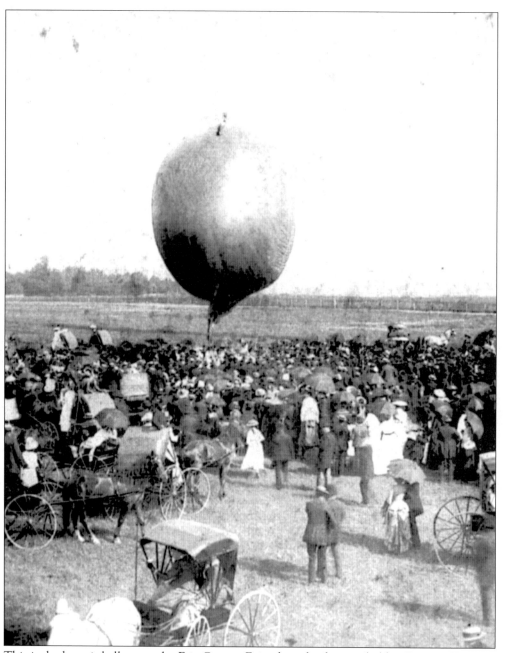

This is the hot-air balloon at the Erie County Fair when the fair was held at Dygert's Farm on Elk and Cattaraugus Streets in Springville. Dygert's had a racetrack and driving range. In 1912, Jim Thorpe, with "Pop" Warner coaching, continued his Olympic training at Dygert's.

A group of local businessmen and professional men from Springville attend a meeting. This was probably in the 1950s or 1960s.

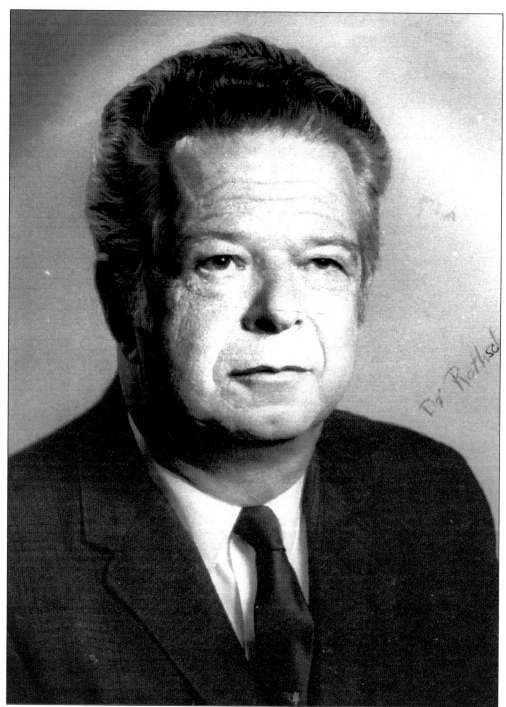

Springville was blessed to have Dr. Edmund Rothschild in the community. He was always available on the telephone or to squeeze a patient in for an office call. Phyllis Salisbury, his receptionist, always said, "Doc will be right with you." If he thought a patient needed further checking, he would make a house call. He established the Concord Medical Group in Springville, but he also established himself in the hearts of residents. He retired in August 1979.

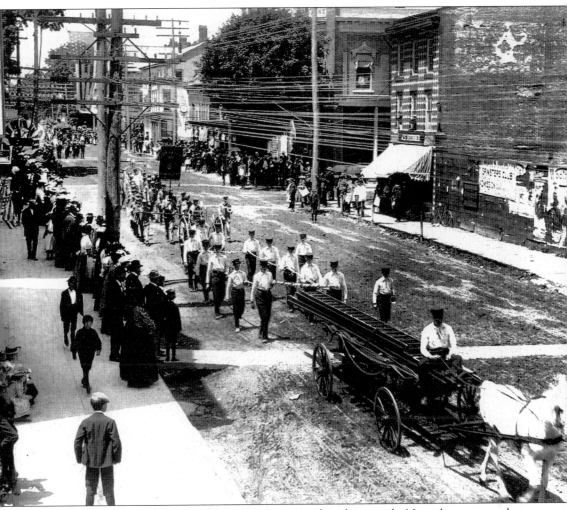

An early firemen's parade passes down Main Street in this photograph. Note the store on the corner. It is one of the very oldest remaining today, now occupied by the Carolsel Shop.

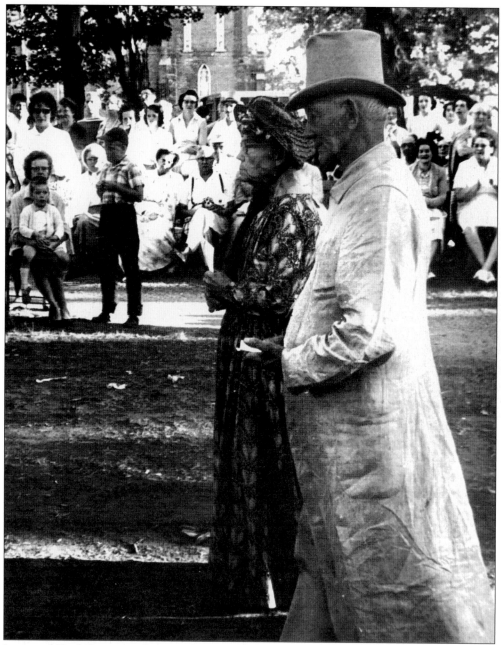

Jessie and Hugh Potter are shown in 1962 at the town of Concord sesquicentennial celebration. They were the parents of Will Potter, who is best known as the local auctioneer.

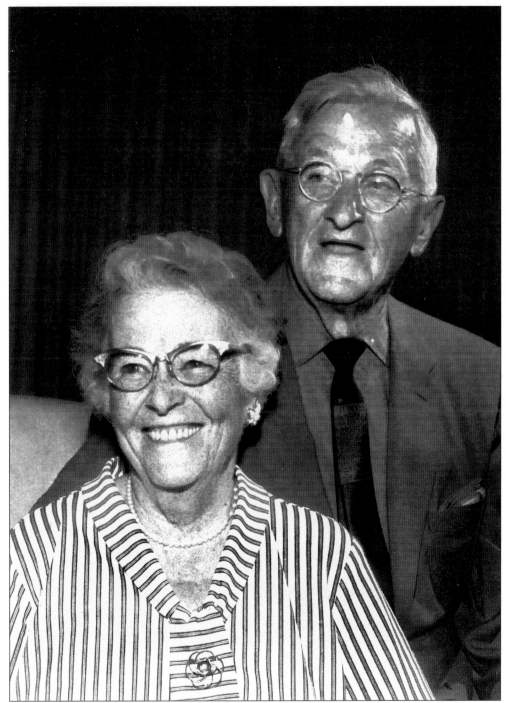

George Schuster and his wife, Rose, are pictured here. George was known as the winner of the "Great Automobile Race" from New York to Paris by land. He raced in a Thomas Flyer in 1908 and made the trip in 169 days, covering 13,341 land miles. His great-grandson Jeff Mahl captured the thrill of the race in his book by the same name written in 1992. The Flyer is now in a museum in Reno, Nevada.

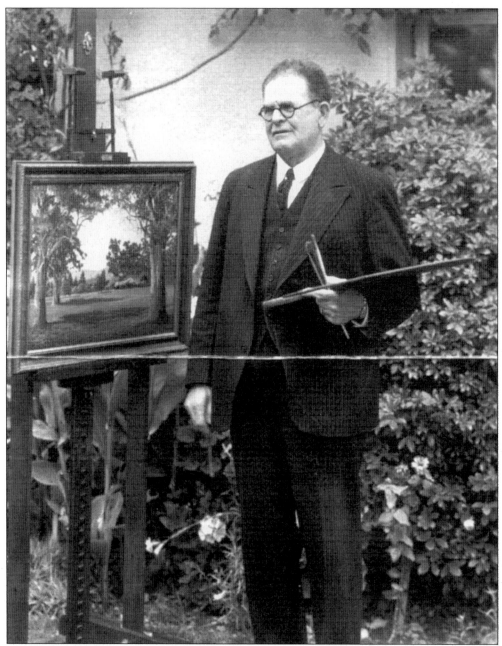

The beloved Glenn "Pop" Scobey Warner died at the age of 83 and is buried in Maplewood Cemetery. He and his wife, Tibb, donated the money to purchase the Bianca Bement house, at 98 East Main Street. The house became the home of the Concord Historical Society and is now called the Warner Museum.

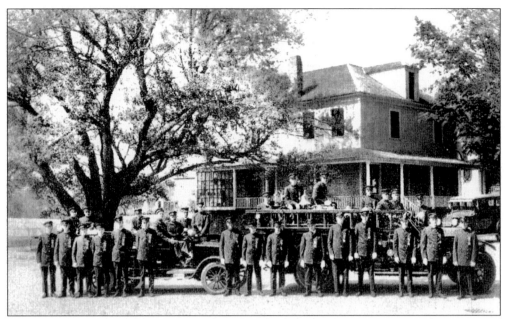

Springville's finest firefighters are pictured with their latest equipment at the corner of Woodward Avenue and South Buffalo Street near the log cabin.

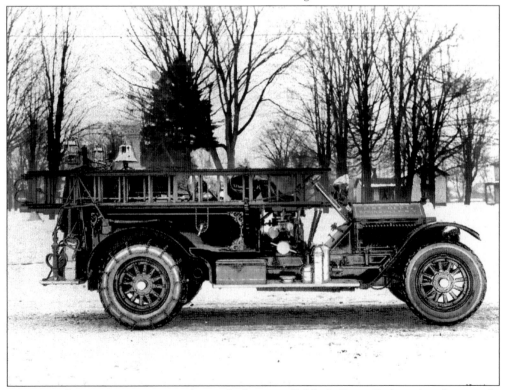

A Springville Fire Department truck is parked next to Fiddler's Green Park in this photograph. Note the bell on the truck. The wheels are fitted with chains. The Kruse home can be seen in the background.

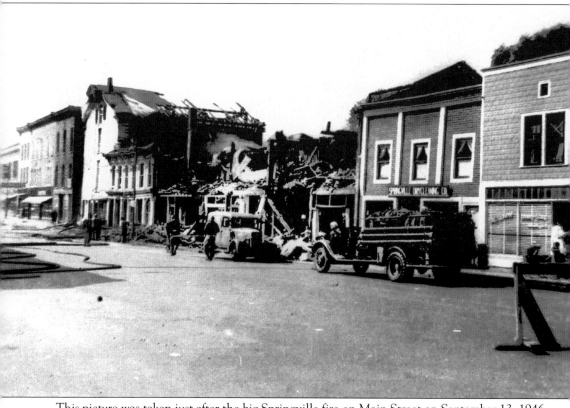

This picture was taken just after the big Springville fire on Main Street on September 13, 1946.

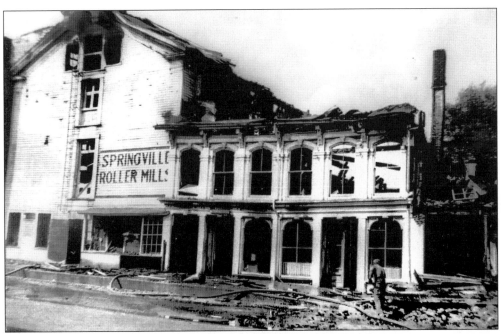

These views show some of the damage done by the September 1946 fire.

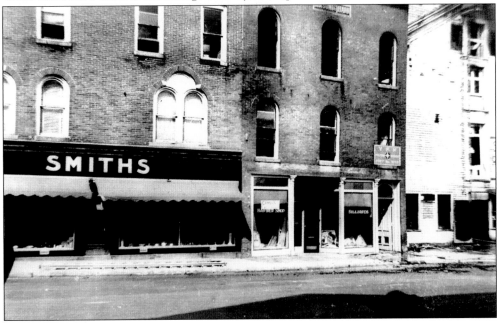

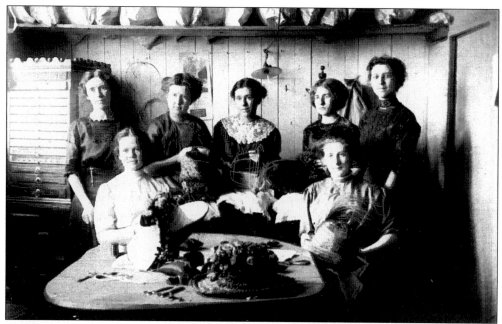

The Home Economics Club was the forerunner of the Home Bureau for women. The following pictures depict their activities and their modern equipment *c.* 1915. The first activity, shown here, is hat making. Olive Shaw is in the front row on the right.

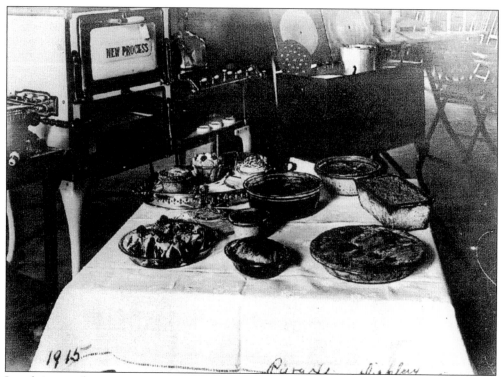

Lunch is served.

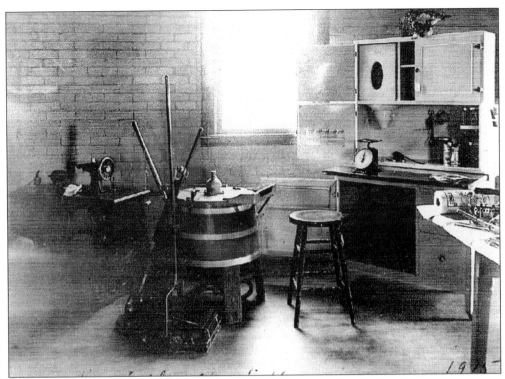

A modern kitchen is pictured c. 1915.

This is a bread-rising machine.

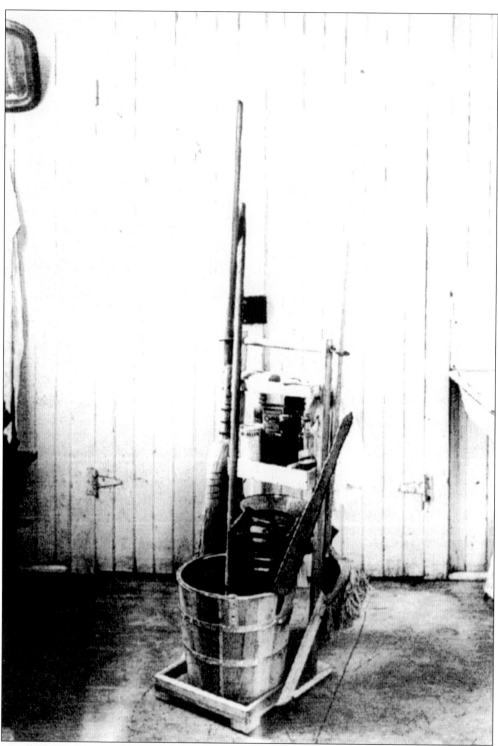

The latest in cleaning devices c. 1915 are shown here.

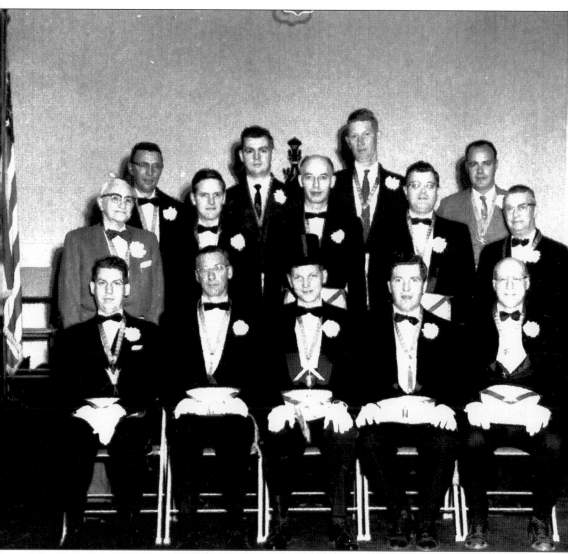

Members of the Masonic lodge are pictured in the mid-1960s. They are, from left to right, as follows: (front row) Roland Smith, Harold Hauenstein, William Lowe, Robert Smith, and Leslie Cambier; (middle row) Robert Mahl, Donald Sheret, William Jax, Paul Frank, and Theodore Hamilton; (back row) Robert McClelland, unidentified, Nels Anderson, and ? Schrader.

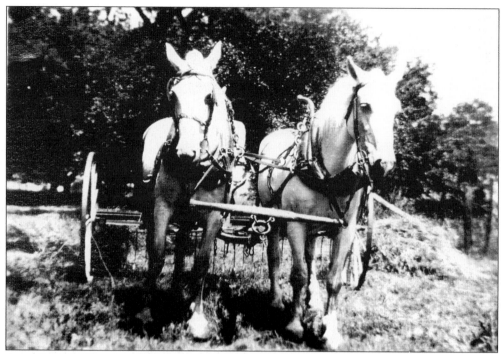

A good team of horses was every man's dream and was a necessity back then for most families.

The Edwin A. Scott Farm, as it was known, was located outside of Springville. It was occupied by Mr. and Mrs. Will Chaffee and their 10 children when this picture was taken in 1918.

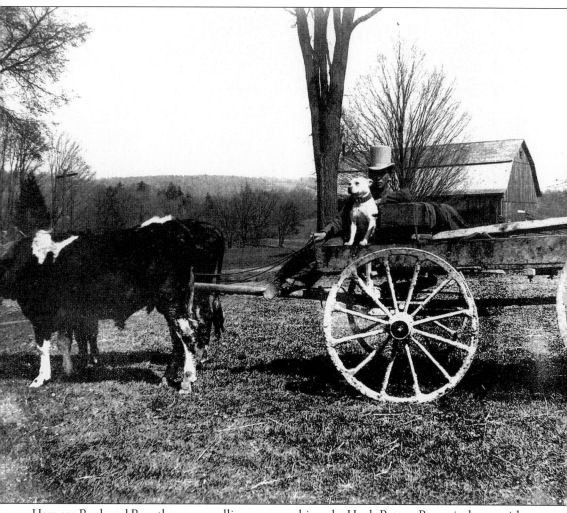

Here are Rock and Rye, the oxen, pulling a wagon driven by Hugh Potter. Potter is shown with his dog at the farm on Snyder Road.

Someone's favorite cat wants no part of "modern" transportation.

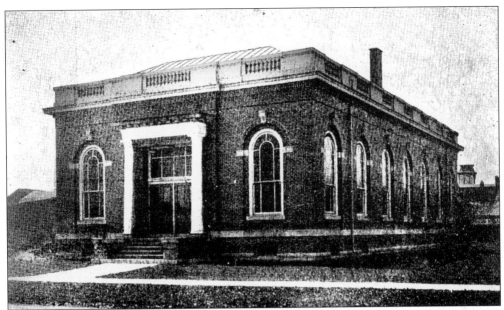

The money to build Godard Hall, shown in its original state, was donated by Calista Godard. This picture was taken in 1910. Later renovations added an upper floor to the building, as we know it today.

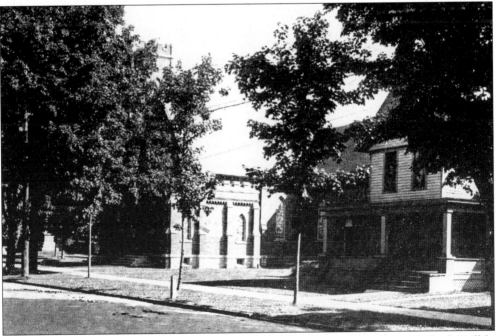

The original Free Will Baptist Church was located at the corner of Franklin and North Buffalo Streets. Years ago, there was also the First Baptist Church at Buffalo and Church Streets. This church was later sold, and the congregation united with the Free Will Baptist Church to become today's First Baptist Church.

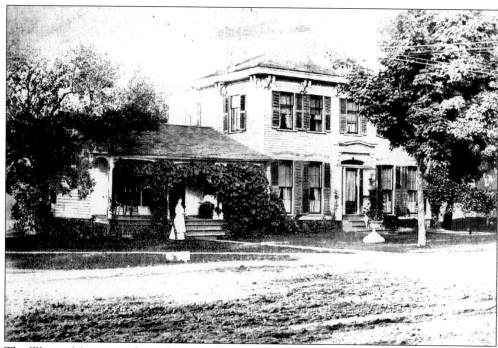

The Warner Museum is shown here in an early view. The building was purchased with money given to the historical society by Glenn "Pop" Scobey Warner and his wife, Tibb.

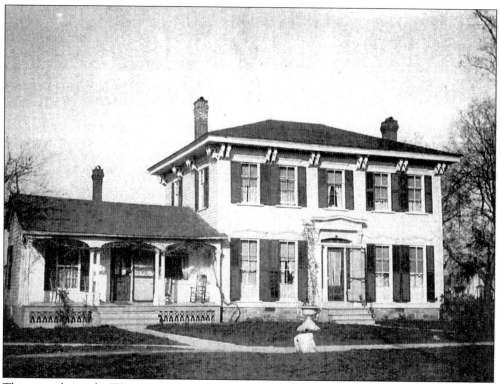

This view shows the Warner Museum after some landscaping was done.

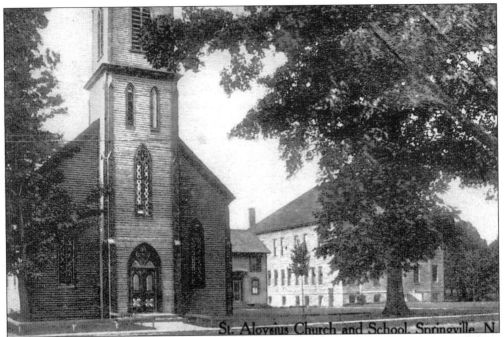

This is St. Aloysius Church (locally known as St. Al's), built in 1879. Reverend Father Fromholzer was the first priest of the church. The building to the right is the school, which is still in use today.

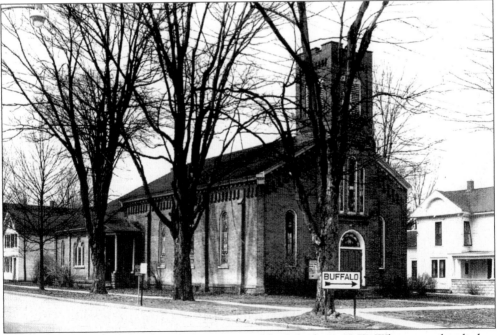

This is the Methodist church and the parsonage, both built in 1863. When completed, they were appraised to be worth a total of $10,000. In 1958, the congregation moved to its new location on East Main Street. The old church and house were torn down and replaced by the Parkside Apartments.

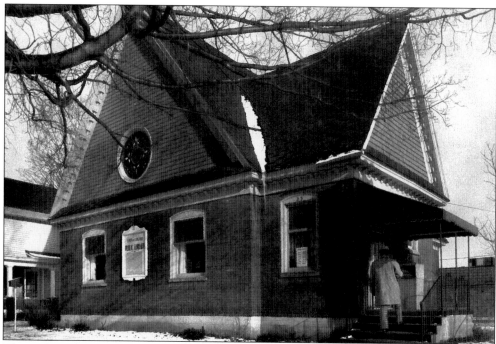

This is the old library at 23 North Buffalo Street with the beautiful stained-glass window in the peak. It was originally built as the Universalist church, where services were first held on December 16, 1897. Some years later, it became the Springville Public Library. It remained in use until the new library was built on Chapel Street. On December 16, 1997, exactly 100 years to the day, the building was rededicated as the Lucy Bensley Concord Historical Genealogical Library.

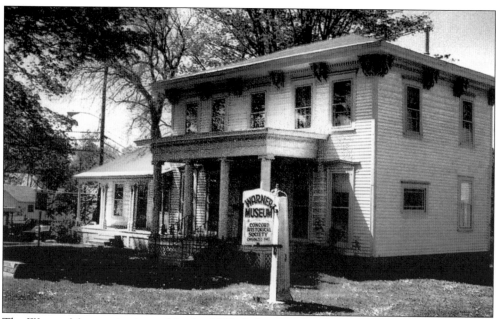

The Warner Museum is pictured in the 1990s before a picket fence and gardens were added.

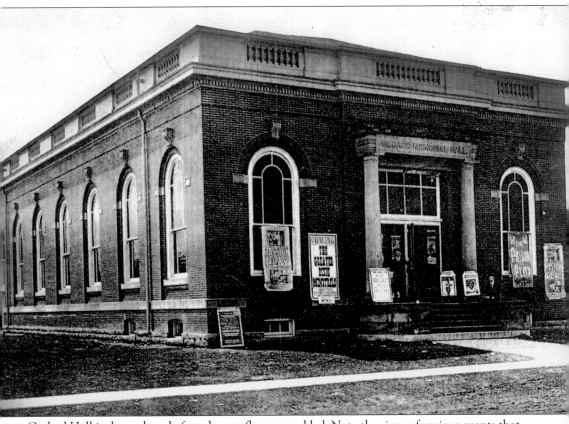

Godard Hall is shown here before the top floor was added. Note the signs of various events that were scheduled here.

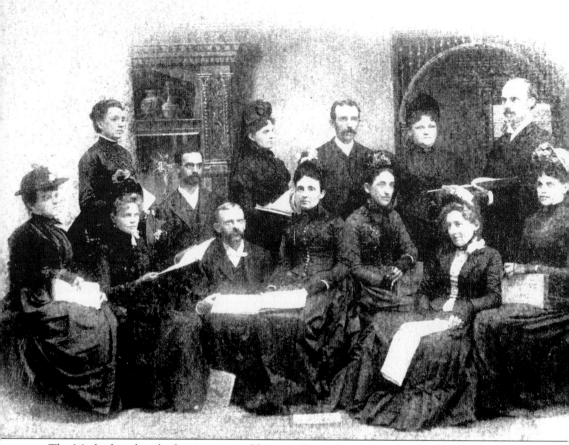

The Methodist church choir is pictured here on December 21, 1889. From left to right are the following: (front row) ? Leland, Mrs. Ira Woodward, Dr. Sewell Glazier, unidentified, ? Torrey, ? Cummings, and Mrs. George Reynolds; (back row) Lucy Sherman Teft, Mrs. Everett Stanbro, Mrs. Hugh Leland, George Reynolds, Mrs. A.D. Jones, and Professor Griffith (principal of Griffith Institute).

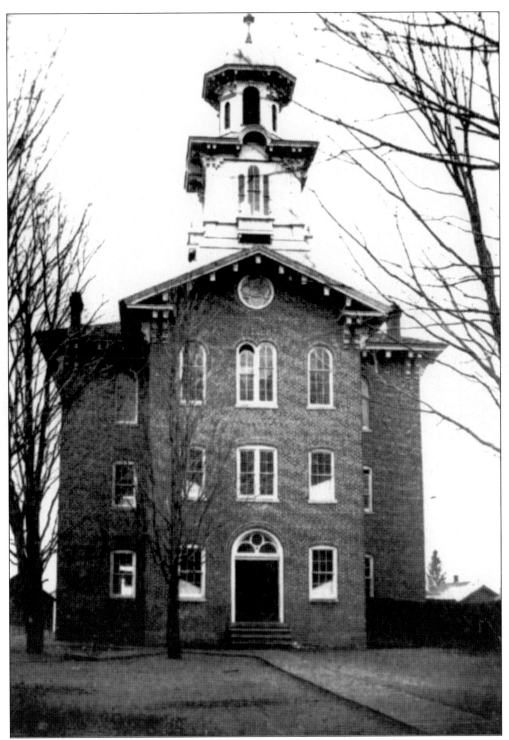

This school, originally the Springville Academy, became Griffith Institute in 1867. At that time, Archibald Griffith gave a substantial amount of money to fund education for less fortunate children, and the name was changed in his honor.

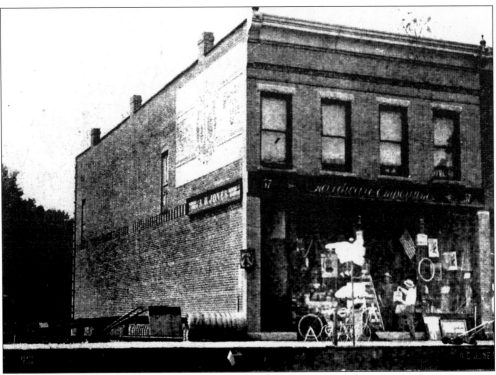

The Hardware Emporium, at 57 Main Street, was the place to find things that could not be found anywhere else. It was owned by Avery D. Jones and is listed in the 1886 *Springville Directory*.

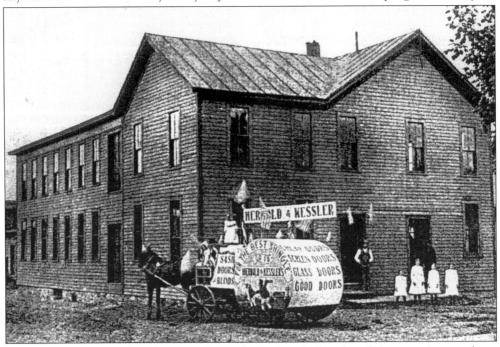

The Herbold and Kessler planing mill was located at 9 Woodward Avenue. It was also a contracting business.

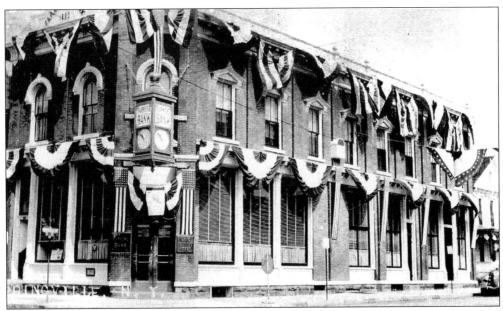

In this view, the old Farmers Bank, at the corner of Main and Mechanic Streets, is decorated for an occasion. Mounted on the bank was a wonderful old clock that chimed the hour and half-hour. Schoolchildren and adults alike abided by this clock.

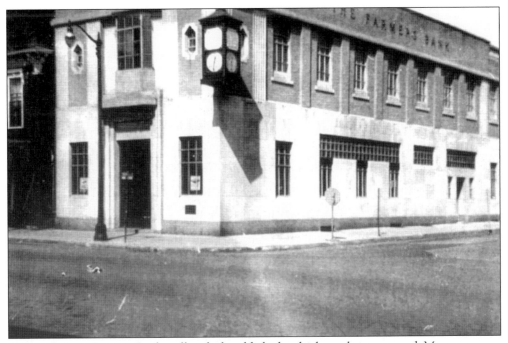

Here is the new Farmers Bank, still with the old clock, which was later removed. Many attempts have been made to regain possession of the clock. Note the stop sign on the sidewalk. At the time this photograph was taken, Mechanic was a two-way street.

1886

WESTERN HOUSE,

SPRINGVILLE, N. Y.

Near Buffalo, Rochester & Pittsburg Depot.

BRANCH OF THE

MAGNUS BECK BREWING CO. AND BOTTLING WORKS,

OF BUFFALO, N. Y.

NOEL F. DUCHENE, Prop'r,

169 and 171 MAIN STREET,

First-class Accommodations for Traveling Public

Noel F. Duchene, Agent,

WESTERN BOTTLING CO., L'T'D, OF BUFFALO.

A page from the 1886 *Springville Directory* is shown here.

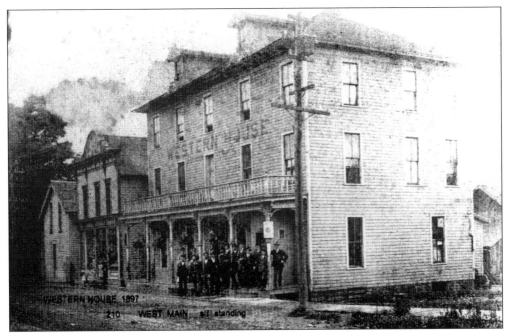

This building is still an active business and meeting place. The rooms are no longer in use for travelers.

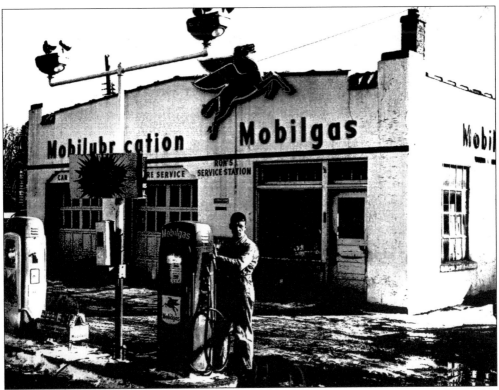

Ron Farner's gas station, on the corner of Mechanic and Franklin Streets, is pictured in 1956.

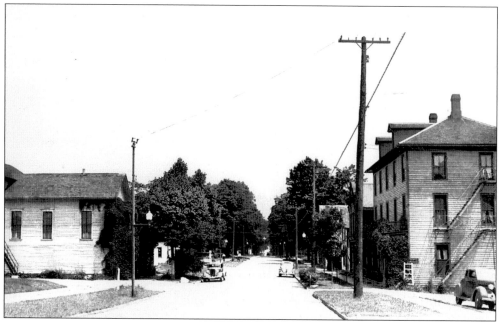

This view of West Main Street looks toward the business center. The Western House is the first building on the right.

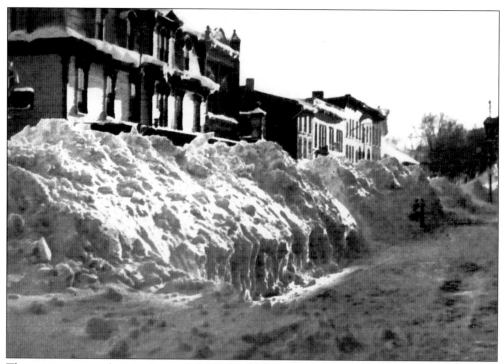

This picture was taken in front of the Leland House in 1945. Only the roof of the portico is showing.

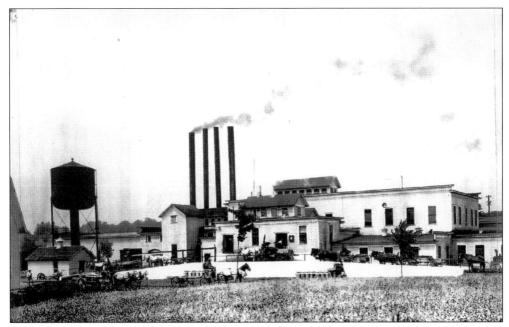

The photographs on this page show the Condensery Plant. In 1915, Borden's installed an ice plant on the company's property on Waverly Street.

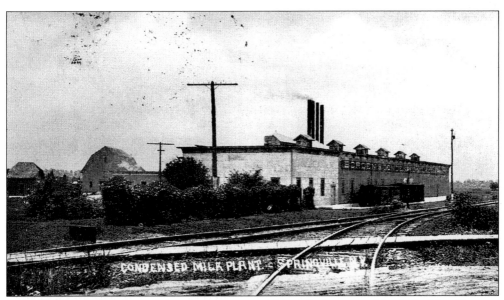

Stanley Lazell made a beautiful replica of a wagon drawn by horses and loaded with milk cans. The replica, on display at the Lucy Bensley Library, is like the one Lazell's father drove to Borden's every day.

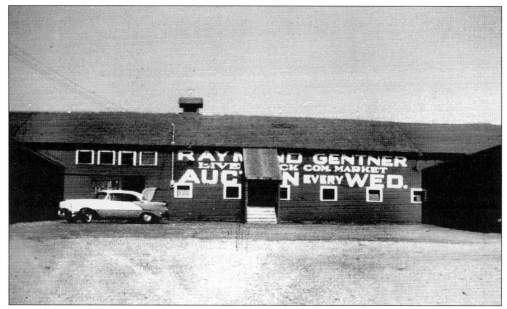

Welcome to one of Springville's greatest attractions—Gentner's Commission Auction, which began in 1913. It was started as a livestock auction and has remained the same. Later, it also became a flea market (held every Wednesday, rain or shine). You have not lived until you have searched for treasures at "the Auction."

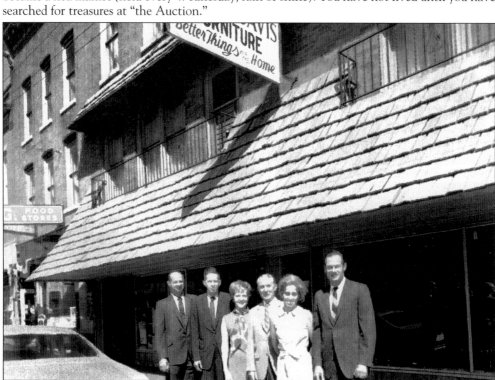

The old and new owners of the Witter Davis furniture store, located on Main Street, are shown here. From left to right are Stanley Krezmien, Philip Davis, Mary Smith, Nelson Witter, unidentified, and Francis Krezmien.

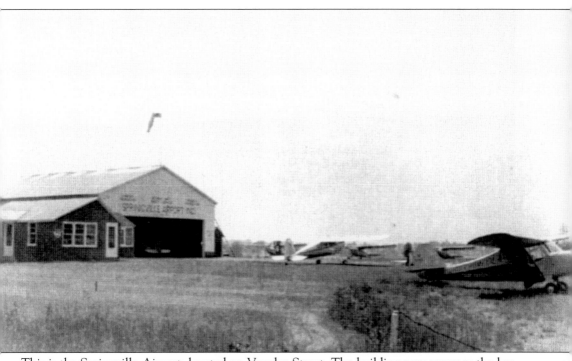

This is the Springville Airport, located on Vaughn Street. The building now serves as the bus barns for Griffith Institute. The airport opened in 1947, and many learned to fly here, including farmers and students.

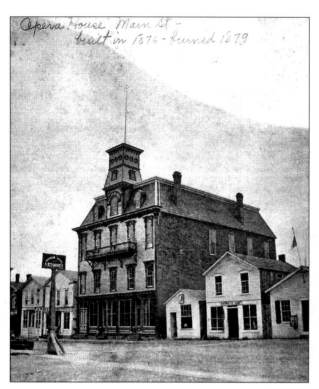

The Opera House, built on Main Street in 1876, burned in 1879.

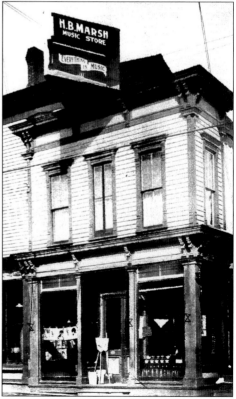

Hiram B. Marsh's music store was located at 148 Main Street. The 1912 *Springville Directory* lists Marsh, his wife (Ida), and daughters (Hazel and Lisla) as living at 2 Park Street. His full-page advertisement in the directory listed player pianos for only $375. A caption for the advertisement read, "This musical wonder would be the greatest blessing that ever came into your home."

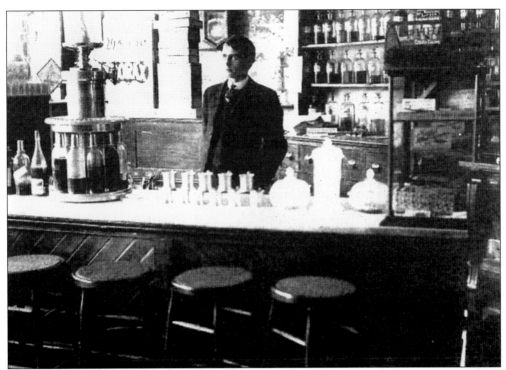

In 1920, Bryon Walters opened a drugstore in the building on the corner of Mechanic and Main Streets. The establishment served as a drugstore and soda fountain. Walters was also noted for his fine singing voice.

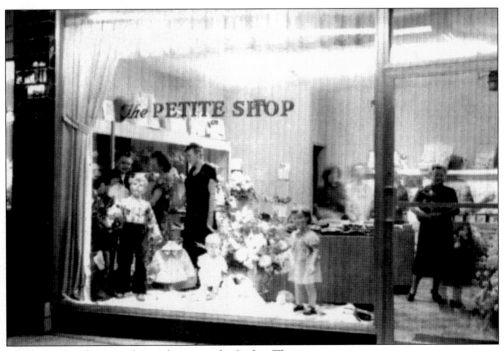

This specialty shop was located next to the Joylan Theater.

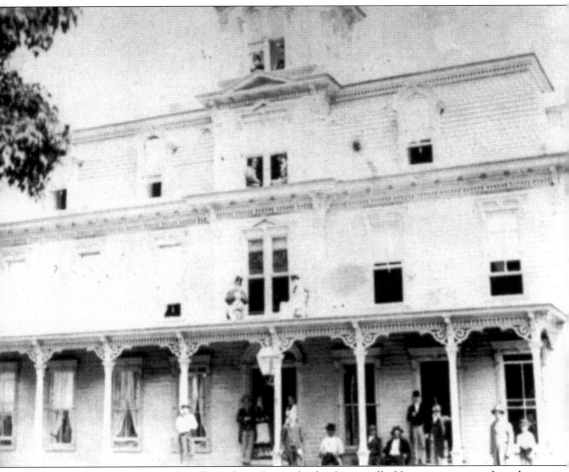

This is the Leland House in all its glory. Formerly the Springville House, it was purchased in 1877 by H.G. Leland, who renamed it. The Springville House was the ninth hotel built on that same location by Rufus Eaton.

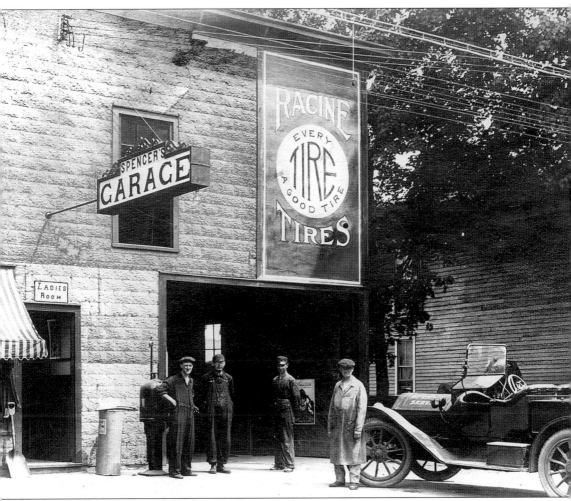

The Spencer garage and machine shop, at 50 Buffalo Street, was organized around the time of World War I and continued up to World War II. It was located on the present site of Spring Brook Apartments. This photograph was taken c. 1919 or 1920. The truck is a 1913–1915 Cadillac with a four-cylinder engine. To the right is the home of druggist Allen Folts. Eleanor Gale, who for many years was Griffith Institute's French and Latin teacher, lived in the upper apartment of the Folts house.

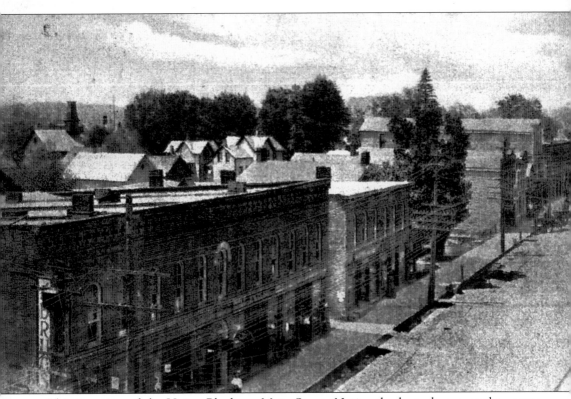

This is a view of the Union Block on Main Street. Notice the horseshoe over the center upper window.

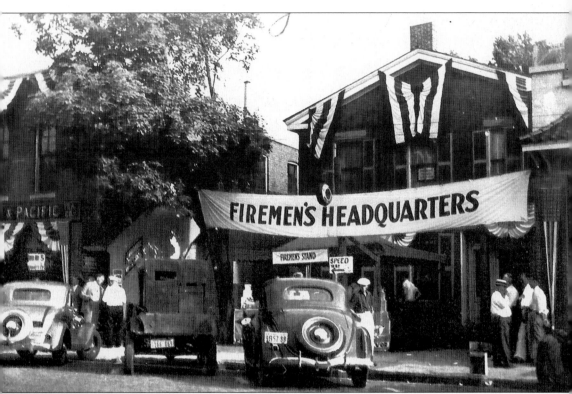

Everyone here is ready for the firemen's parade. The A & P building now houses the Springville Center for the Arts and the *Springville Journal*. The steep steps on the side of the building are still there with the enclosed staircase. The little house next door was the Blakely House, where Helen Brogan's real estate office is now located.

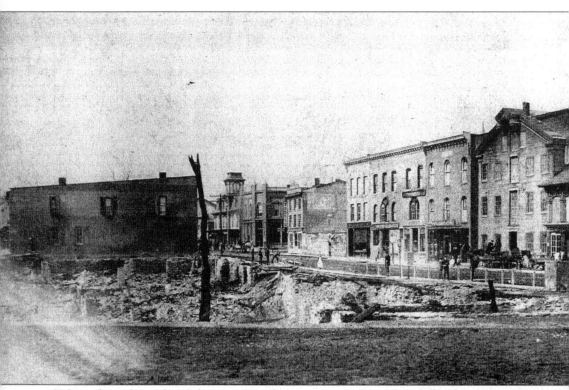

Taken after a fire in late February 1894, this photograph shows the south side of Main Street from Pearl Street. Everything from the Simon Brothers building to Pearl Street burned.

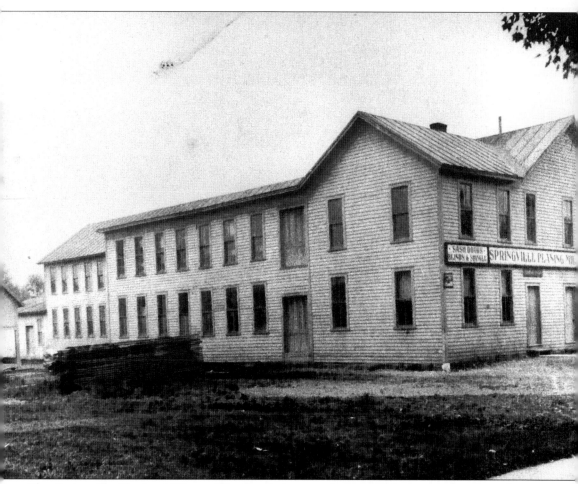

The Springville Planing Mill, on Woodward Avenue, is pictured here. At one time, the building housed a box factory and, at another time, a shoe factory.

This is a page from the 1886 *Springville Directory*, which verifies that the building on Woodward Avenue was once a box factory.

This page was found in the wall of the shoe factory at the former Springville Planing Mill location. Perhaps they sold their shoes to D.W. Blood Company of Albion, New York, whose ad was also found with the information.

Infants' Turn Shoes, Sizes 2 to 5.

No	Kind.	Style	Tip	Price
3	Bt. Dongola Button	Opera	Dong.	$.45
5	Bt. Dongola Button	New York	Pat. Lea.	.50
6	Bt. Dongola Button	Fat Baby		.50
25	Bt. Dongola Foxed Button	Opera	Dong.	.40
27	Bt. Dongola Sole Lea. Foxed Button	Opera	Dong.	.50
1	Black Cloth Bt. Dongola Foxed Button	Opera		.65
18	Wine or Blue Velvet Bt. Dong. Foxed Button	Opera		.60
19	Wine or Blue Ooze Calf Bt. Dong. Foxed Button	Opera		.70
26	Gray Cloth Bt. Dong. Foxed Button	Opera		.65
21	Chocolate Goat Button	French		.70
17	Tan Kid Lace	Fat Baby		.80
16	Black Ooze Calf Button	French		.75
96	Tan Goat Button	French		.60
15	Red Goat Button	French		.60
13	Chocolate Kid Button	New York		.70
12	Vici Kid Button	French		.80
11	Vici Kid Button	New York		.70
10	Bt. Dongola Button	Opera		.60
8	Russia Calf Button	French		.80
7	Bt. Dongola Lace, Ankle Support	New York		.80

Infants' Turn Shoes, Wedge Heel.

No	Kind.	Style	Tip	Price
22	Bt. Dongola Foxed Button, 2 to 5	Opera	Dong.	.50
24	Bt. Dongola Button, 3 to 6	Opera	Dong.	.60
30	Bt. Dongola Button, 5 to 8	Opera	Dong.	.65
14	Vici Kid Button, 3 to 6	French		.80

Children's Turn Shoes, Spring Heel, 5 to 8.

No	Kind.	Style	Tip	Price
49	Bt. Dongola Button	French	Pat. Lea.	$.8.
38	Bt. Dongola Button High Cut	Opera		1.00
32	Vici Kid Button	French	Pat. Lea.	.95
33	Vici Kid Button	French	Pat. Lea.	1.05
97	Tan Goat Button	French	Tan Goat	.80
43	Chocolate Goat Button	French	Choc.Goat	.90
40	Chocolate Kid Button	French	Choc. Kid	.50
29	Russia Calf Button	French	Rus. Calf	1.00
31	Tan Kid Lace	Opera	Tan Kid	.90
4	Black Cloth Bt. Dongola Foxed Button	Opera	Pat. Lea.	.90
48	Red Goat Button	French	Red Goat	.80
44	Wine or Blue Ooze Calf Bt. Dong. Foxed Button	Opera		.85
46	Wine or Blue Velvet Bt. Dong. Foxed Button	Opera		.80
23	Gray Cloth Bt. Dong. Foxed Button	Opera		.80
45	Black Ooze Calf Button	French	Bl'k Calf	1.00

Children's McKay Shoes, Spring Heel, 5 to 8.

No	Kind.	Style	Tip	Price
9	Kangaroo Calf Button	Opera	A. S. T.	.80
41	Pebble Goat Button	Opera	Peb. Goat	.80
28	Bt. Dongola Button	Opera	Pat. Lea.	.85

Children's McKay Shoes, Spring Heel, 8 to 11.

No	Kind.	Style	Tip	Price
54	Bt. Dongola Button	French		1.00
80	Bt. Dongola Button	New Phil.	Pat. Lea.	1.05
36	Bt. Dongola Button High Cut	French		1.25
81	Vici Kid Button	New Phil.	Pat. Lea.	1.30
48	Tan Goat Button	New Phil.	Tan Goat	1.00
75	Chocolate Goat Button	New Phil.	Choc.Goat	1.20
50	Chocolate Kid Button	New Phil.	Choc.Kid	1.20
83	Russia Calf Button	New Phil.	Rus. Calf	1.30
63	Black Ooze Calf Button	New Phil.	Pat. Lea.	1.30
71	Kangaroo Calf Button	Opera	A. S. T.	1.00
57	Pebble Goat Button	Opera	Peb. Goat	1.00
85	Russia Calf Button High Cut	French		1.50

PHILLIP HERBOLD,

CABINET-MAKER, UNDERTAKER & EMBALMER

All Kinds of Furniture Made

AND KEPT ON HAND.

PROPRIETOR OF THE

SPRINGVILLE PLANING-MILL,

Sash, Blind and Door Factory.

Ware Rooms 72 and 74 Main Street,

SPRINGVILLE, N. Y.

An 1886 ad in the *Springville Directory* shows another business in the Springville Planing Mill.

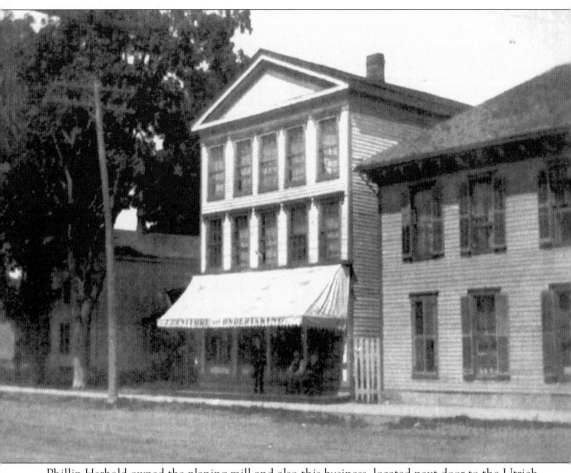

Phillip Herbold owned the planing mill and also this business, located next door to the Utrich Boarding House on Main Street.

J. H. UTRICH,

CENTRAL HOUSE,

No. 118 Main Street,

First-Class Accomodations

FOR THE TRAVELING PUBLIC.

An ad from the 1886 *Springville Directory* advertises the Central House, owned by J.H. Utrich.

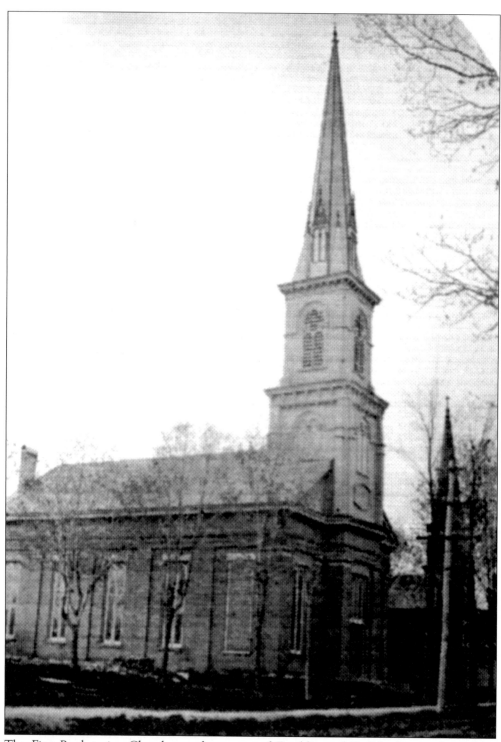

The First Presbyterian Church, on the corner of Franklin and Buffalo Streets, burned on February 21, 1921. Lillian Geiger remembered sitting on the curb across the street as a child and crying as her church burned.

This was the summer home of artist Roberta Parke and her sister. Located on Vaughn Street, the house was built between 1813 and 1826.

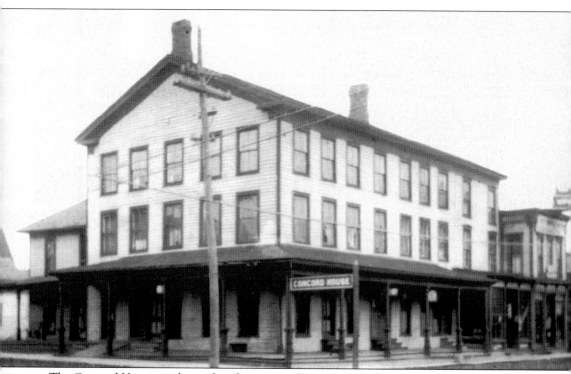

The Concord House was located at the corner of Main and Buffalo Streets in the 1890s. Today, the E-Z Shop is at this location.

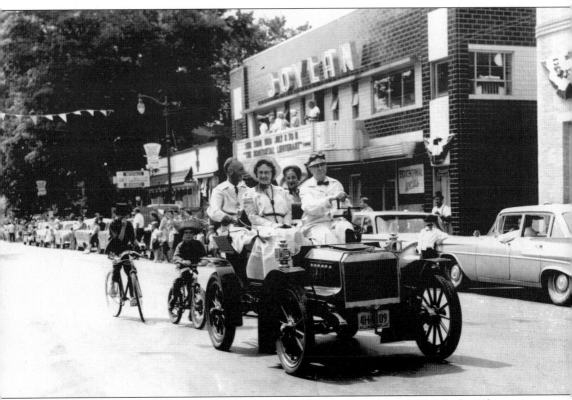

Shown is a 1949 parade down Main Street. In the background is the remodeled Joylan Theater. The original Joylan opened in 1930.

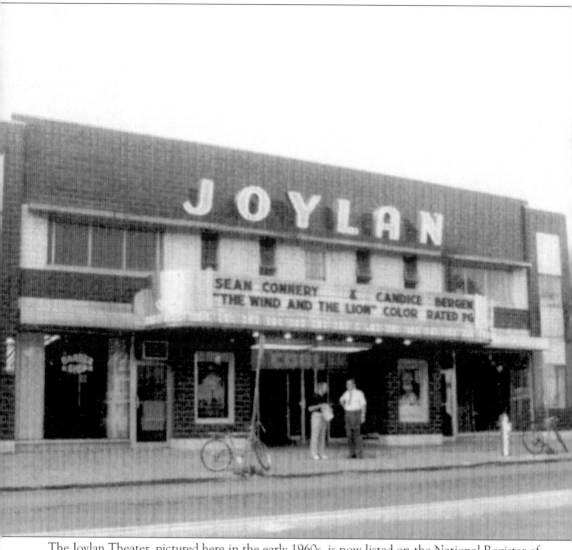

The Joylan Theater, pictured here in the early 1960s, is now listed on the National Register of Historic Places.

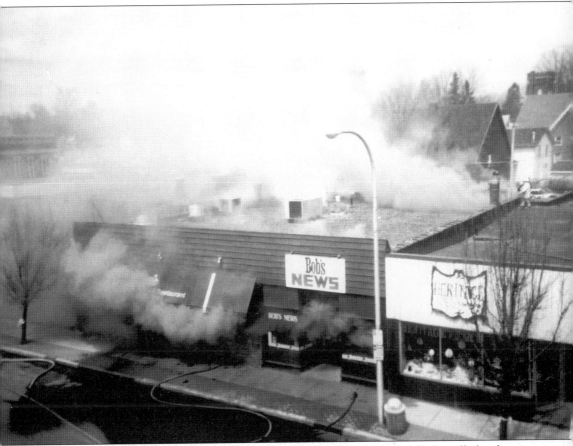

This picture was taken on Good Friday, April 18, 2003, before 2:00 p.m. Springville has been ravaged by fire many times, but in 2003, there were two terrible fires. The first was at Gramco Mill on West Main Street, and the second was on downtown Main Street. Julie's Pizzeria and Bob's News were completely destroyed. The Heritage Flower Shop and Metro Real Estate suffered smoke and water damage. Fourteen fire companies did their best and saved the rest of the street from disaster. The photograph was taken from the third floor of the Waite Building, across the street.

This gentleman is shown with his 1926 or 1928 automobile parked on South Buffalo Street.

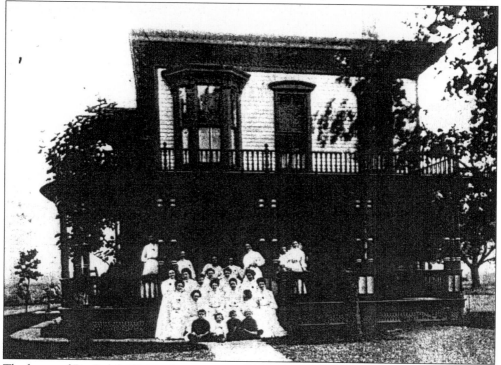

The home of Dr. Ralph Waite, the inventor of Novocain, is located on East Main Street. At a later date, the home was covered with bricks and still remains in wonderful condition.

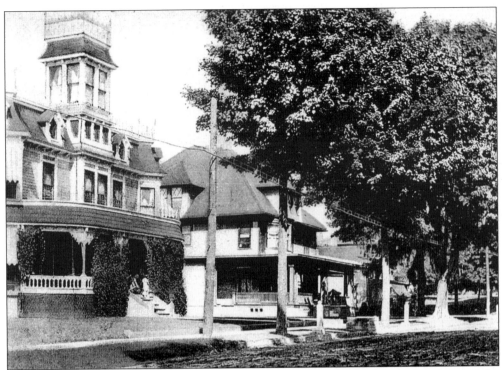

The cupola and the "gingerbread" are gone from Dr. Fred Schweizer's home. The next house to the right is Dr. Lloyd Glazier's home. It was demolished to make way for the Concord Medical Group.

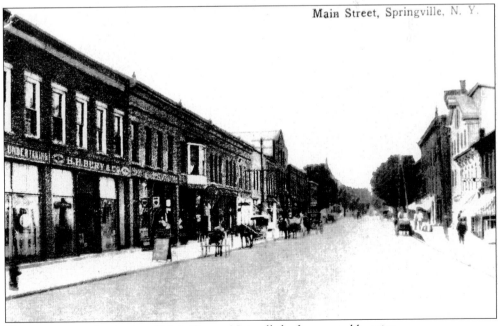

Main Street, Springville, N. Y.

This is a very early picture of Main Street. Note all the horses and buggies.

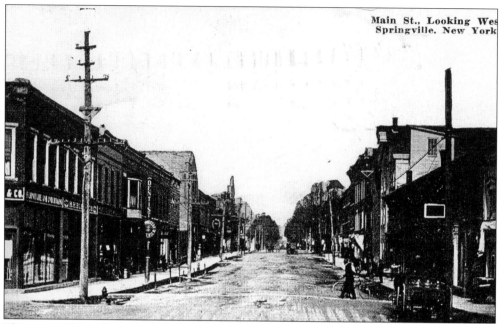

This view of Main Street looks west. The street is under construction with tall telephone poles and street paving. Notice the farmer with his milk cans and horse-drawn wagon. A man is crossing the street with his "wheel."

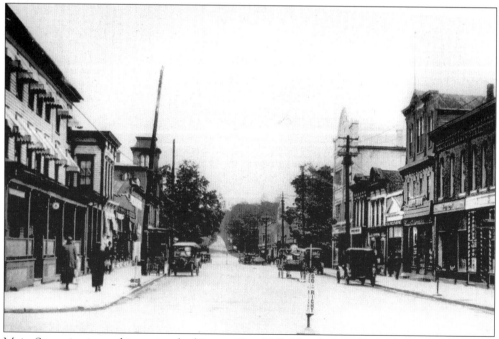

Main Street is pictured in a view looking up East Hill. The Concord House, on the left, stood where the E-Z Shop is now located. Farther down on the left is the Leland House, and on the right is the Waite Building, which is the tallest building in Springville. The "Go Right" sign preceded the stoplight at the corner of Main and Buffalo Streets.

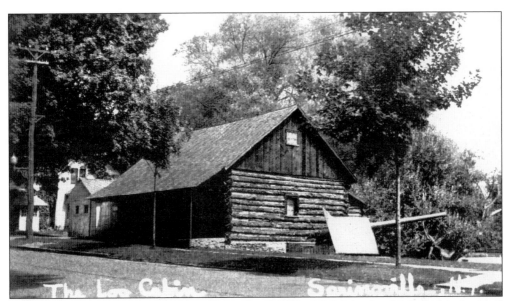

The land on South Buffalo Street was donated in 1892 by J.P. Meyer for this log cabin for Civil War veterans. He also gave land for a fire station. The ladies of the town held programs with refreshments to help pay for the log cabin. The fire station is long gone, and the log cabin was sold by the American Legion when they built their new building on Zoar Valley Road.

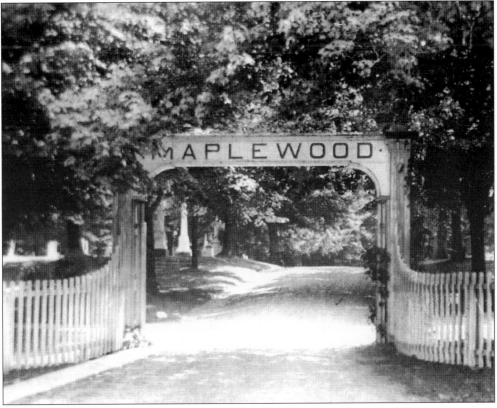

The entrance to Maplewood Cemetery, on West Main Street, is shown in 1909.

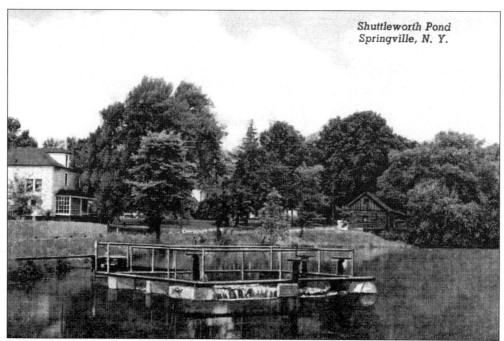

Shuttleworth Pond is shown as it looked from South Buffalo Street before it was drained and turned into a park. Spring Brook still meanders through it. "Shakespeare in the Park" is presented there by the Springville Center for the Arts each summer.

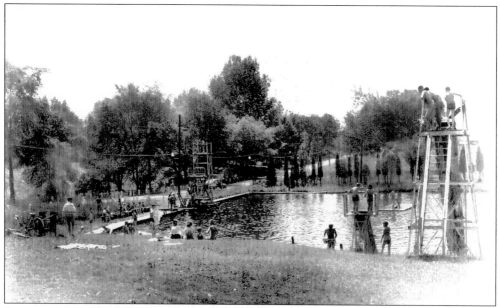

Summer meant "Pete's Pond" in Springville. Locals got a basket from Grandpa Peterson for 25¢, put on a bathing suit, put their clothes and lunch in the basket, and began the day. They swam, played on the swings, and baked in the sun. There was no lifeguard on duty. In those days, the big kids looked after the little kids. Children were not allowed to go beyond the rope until they could swim. There was no pushing or splashing, or swimmers would be called out of the pond.

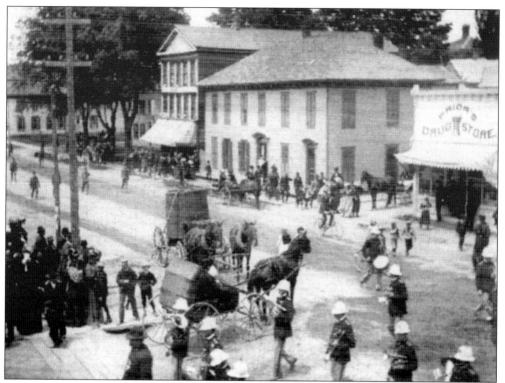

It appears that people are gathered at this busy intersection of Main and North Buffalo Streets to view a parade.

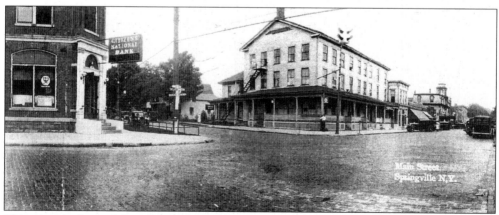

This view looks up Main Street from the intersection of Main and Buffalo Streets in the early 1900s.

A postcard view looks down Woodward Avenue. The name of the street has been misspelled by the postcard company.

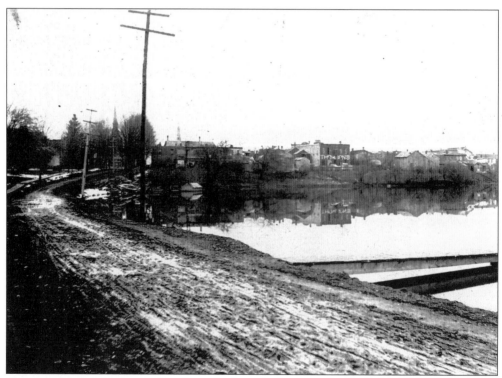

Shuttleworth Pond is pictured in the early days. At the time, South Buffalo Street had not yet been paved.

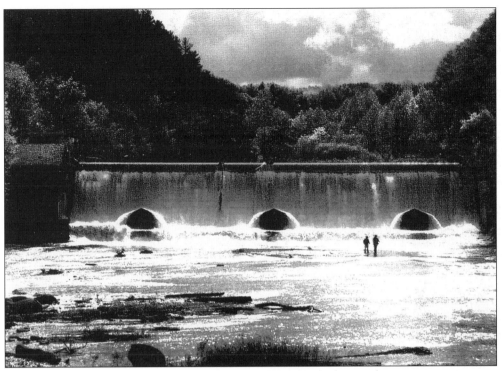

This picture of Scobey Dam shows a fisherman waiting for the big catch.

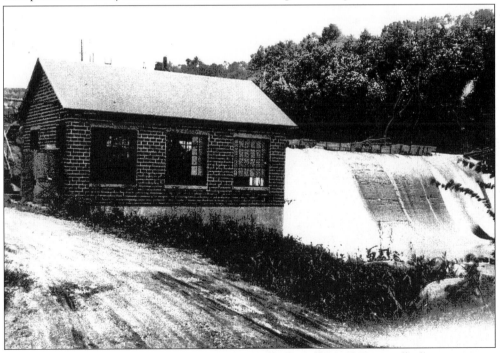

The Scobey Hill Power Dam provided electricity for the village of Springville for many years. It is now on the National Register of Historic Places and is a passive park for those who love nature.

This view looks toward the Civil War monument from Fiddler's Green Park. Shown in the background is the church, then known as the Free Will Baptist Church.

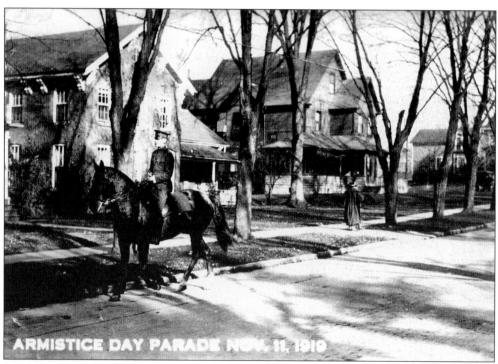

ARMISTICE DAY PARADE NOV. 11, 1919

A rider on East Main Street is going to the Armistice Day parade on November 11, 1919. Note the Presbyterian Manse on the left and the lonely figure on the sidewalk, on the right, who evidently is not going to the parade.

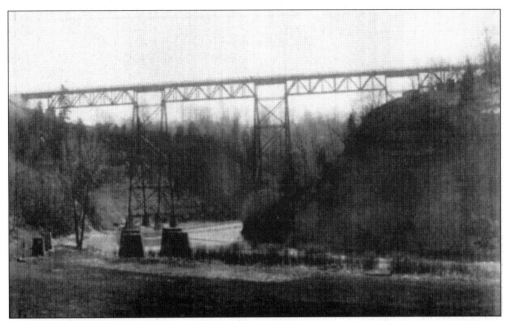

The Buffalo, Rochester and Pittsburgh Railroad trestle crosses over the Cattaraugus Creek just south of Springville.

These tennis courts were located on Woodward Avenue *c.* 1916.

Wesley Chandler is the self-appointed mayor of Springville's wonderful Zoar Valley. He has lived at the entrance for more than 75 years.

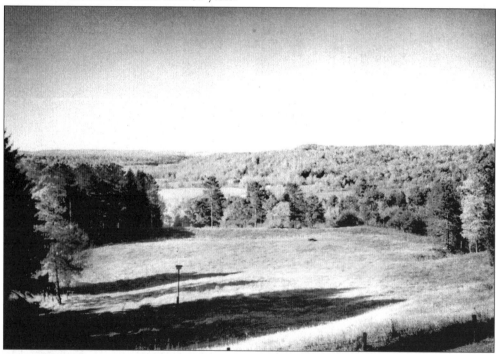

There are many stories and many versions of each story about Zoar Valley. Perhaps the most interesting is about the peddler who stopped at a farmhouse. There was some kind of dispute between the peddler and the owner, and the peddler was thrown into the well. Every time he put his hand on the edge of the well to get out, his fingers were stepped on. He put a curse on the family, and thereafter, everyone born into that family had either webbed fingers or toes.

Zoar Valley covers several thousand acres containing more than 600 acres of trees. These are perhaps some of the oldest and largest in New York State. It is said that some of them were saplings before Columbus arrived here.

The Cattaraugus Creek flows through the valley with deep gorges, waterfalls, and towering cliffs. The area is serene and scenic, wild and surprising, as shown in these pictures.

Wild turkeys can be seen in the valley in the wintertime.

Seen here is a huge tree that has been struck by lightning.

This is the first railroad trestle built across the Cattaraugus Creek. The first train crossed over it on June 9, 1883.

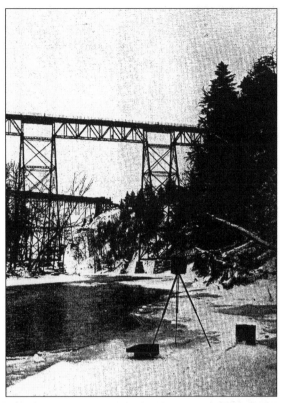

The jail for Springville was housed in the Concord Town Hall in the 1940s.

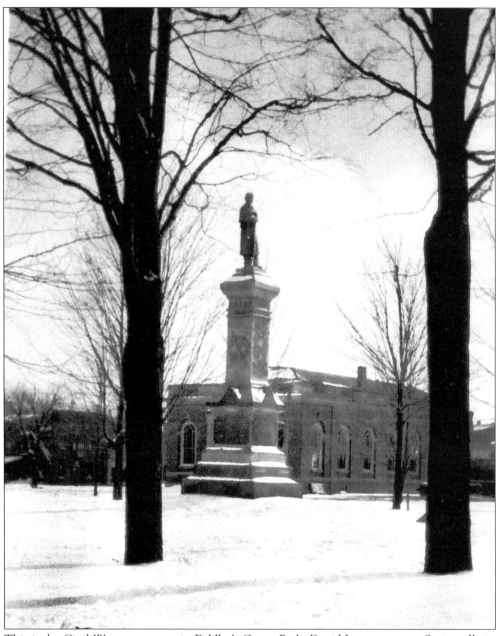

This is the Civil War monument in Fiddler's Green Park. David Leroy came to Springville in 1812 and lived nearby. He and his friends "fiddled" here, thus the name Fiddler's Green. The park was also used later as parade grounds, and traveling shows entertained here. The monument was placed in the park in 1891. The benefactor was David Ingalls. The names of Civil War veterans were inscribed on the monument. One forgotten veteran's name was added in November 1998. He was Cpl. Charles F. Taylor.

Two
MORTONS CORNERS
AND WOODSIDE

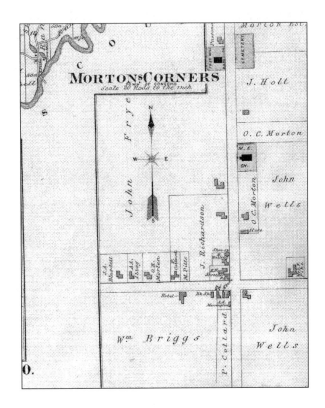

This is a map of Mortons Corners.

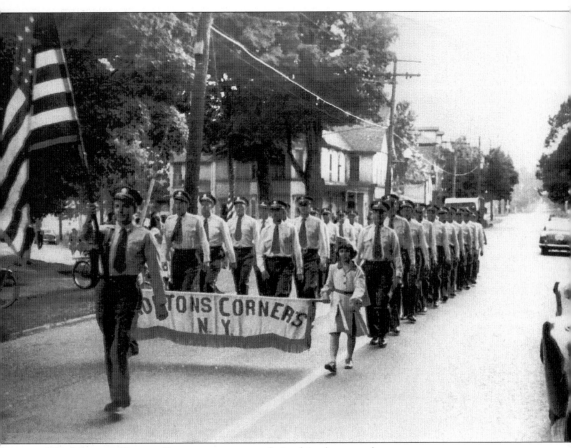

The Mortons Corners firemen are on parade in this photograph.

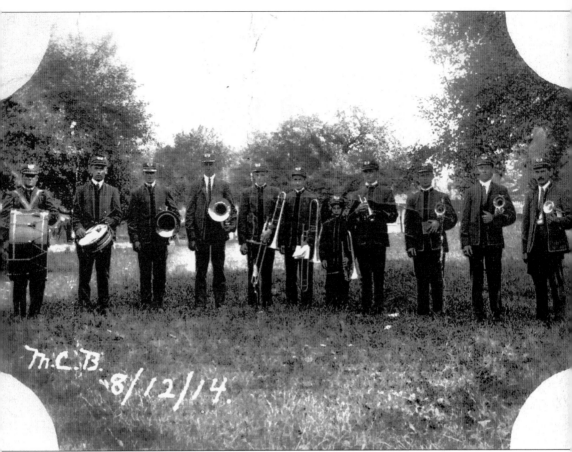

The Mortons Corners Band is lined up and ready to march on August 12, 1914.

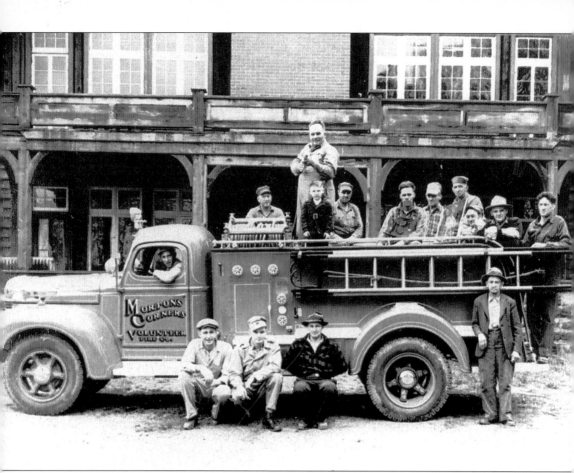

Mortons Corners volunteer firemen show off their truck in front of the Woodside Dance Hall.

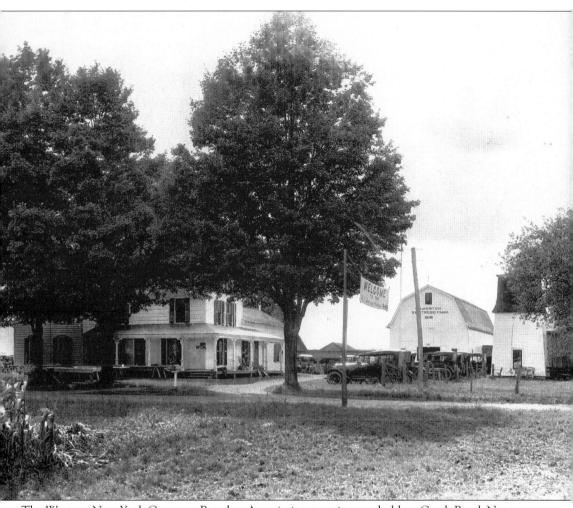

The Western New York Guernsey Breeders Association meeting was held on Groth Road. Note the tables set up for lunch on the front lawn.

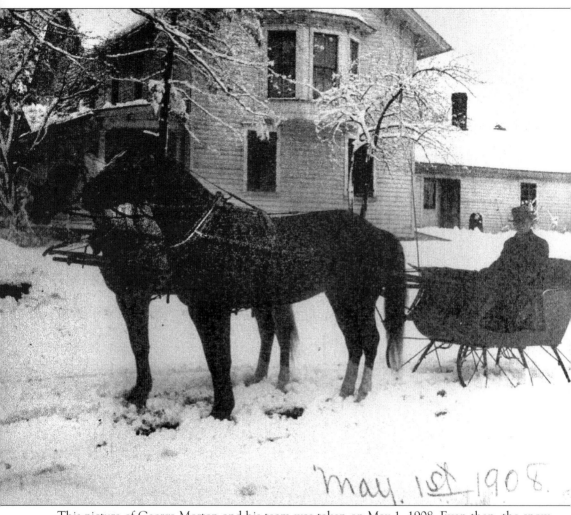

May. 1st 1908.

This picture of George Morton and his team was taken on May 1, 1908. Even then, the snow came late and was probably unexpected. Mortons Corners was named after the Morton family.

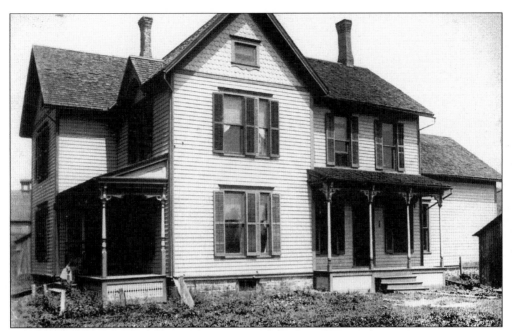

Ira Westendorf's home was located in Wheeler Hollow and burned.

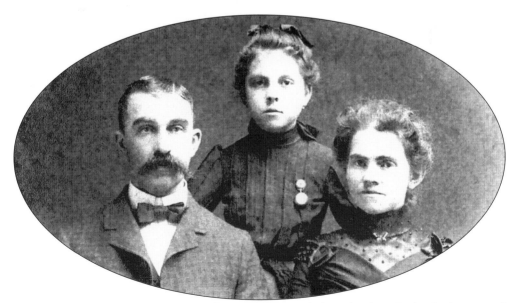

This is a family picture of George and Mary Geiger and their daughter Leska. Leska married Ross Brown, who was co-owner of Woodside at one time.

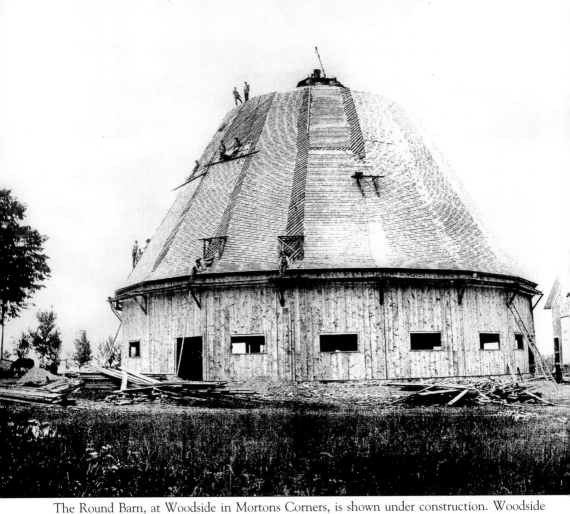

The Round Barn, at Woodside in Mortons Corners, is shown under construction. Woodside consisted of seven farms and the Woodside Dance Hall. The original owners of Woodside, the Richardson family, lived on Farm No. 5.

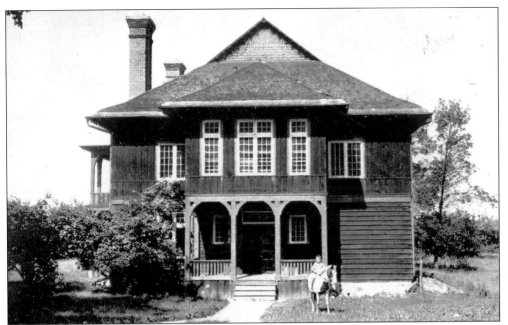

This is another view of Woodside. The child on the pony is a member of the Brown family, who owned the property at one time.

This is the dance floor at Woodside. Many residents of nearby villages remember dancing the night away here.

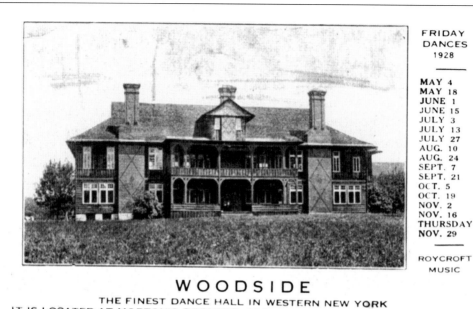

WOODSIDE

THE FINEST DANCE HALL IN WESTERN NEW YORK
IT IS LOCATED AT MORTON'S CORNERS, ABOUT FIVE MILES FROM SPRINGVILLE
SEE OTHER SIDE)

FRIDAY
DANCES
1928

MAY 4
MAY 18
JUNE 1
JUNE 15
JULY 3
JULY 13
JULY 27
AUG. 10
AUG. 24
SEPT. 7
SEPT. 21
OCT. 5
OCT. 19
NOV. 2
NOV. 16
THURSDAY
NOV. 29

ROYCROFT
MUSIC

Pictured is a 1929 advertising card for Woodside. Woodside burned in 1958.

The identity of this young lady in front of Woodside is unknown, but the theory is that the letter *P* on her jacket could have stood for Pittsburgh. That is where Pop Warner coached.

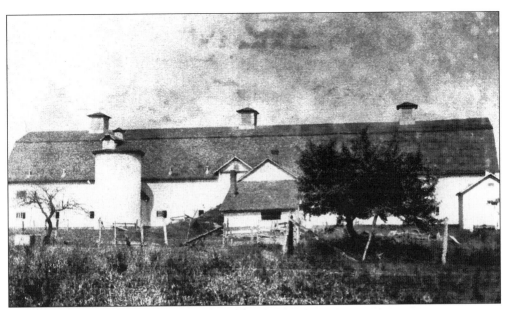

The barn at Woodside Farm No. 1 is shown here.

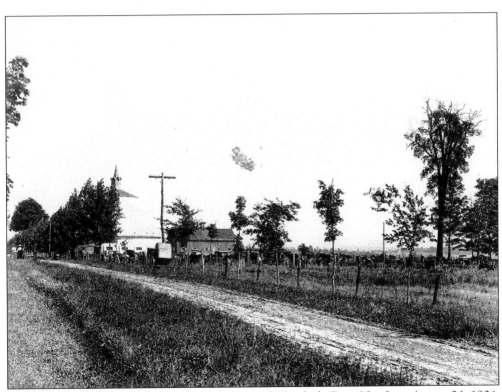

This photograph was taken from the front lawn of Woodside Farm No. 2 on August 26, 1904. Louis Steeles ran the farm at this time, and the Farmer's Institute is having a meeting here on this day.

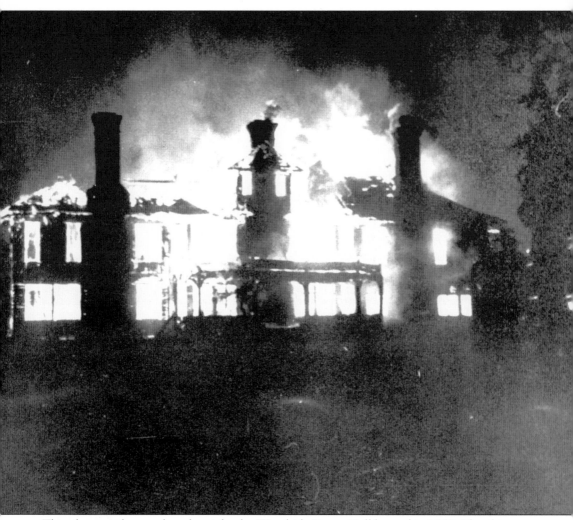

This photograph was taken the night the Woodside Dance Hall burned in 1958. The chimneys are still standing.

Three

WYANDALE

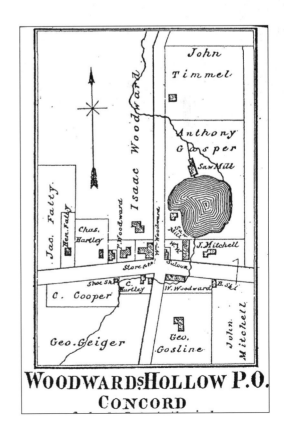

This is a map of Wyandale.

Wyandale During the Golden Days

Wyandale was originally called Woodward's Hollow. It was renamed because Willis Clark, who lived just below the north hill, raised Wyandotte hens.

Between 80 and 100 years ago Wyandale had the following: general store, saloon, cheese factory, two saw mills, tannery, wagon shop, loom house, blacksmith shop, ashery, millinery, furniture shop, post office, shoe shop, barber shop, candy shop, school, night school, and a Doctor Caulkins!

The map shows a mill pond 267 feet across, which operated one of the saw mills. This mill operated night and day to satisfy the huge demand for lumber.

Wyandale was surveyed for a trolley line, which would have connected with Buffalo and gone up the creek as far as Woodside at least. The line would have passed between the Grange Hall and John Gunsher's house. The trolley line was never constructed.

The old country store was a place of excitement day or night. Various owners were Woodward, Hickok, Fattey, Washburn and Warner. The store and corner saw mill each had a dance hall on the second floor. Both buildings were destroyed by fire and rebuilt. Little is known about the saloon—it must have been a wild place with Kitty playing the piano!

Bread and milk were 5 cents each, eggs, 11 cents, butter, 13 cents, maple syrup and cord of wood, $1.00 each, telephone, $1.00, and wages, $1.00 per 10 hour day!

—Gene Fattey, 1978

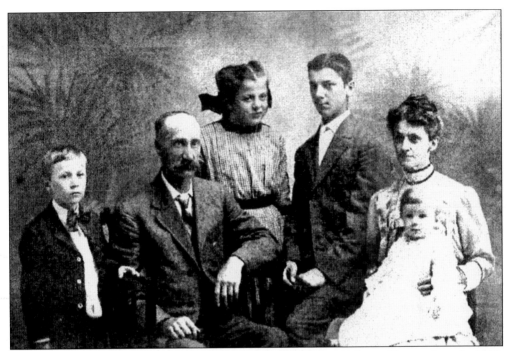

One Fattey family lived in the hamlet of Wyandale. From left to right are Eugene, born in 1907; William (father), born in 1868; Florence, born in 1897; Cecil, born in 1896; Emma Kern Fattey (mother), born in 1870; and Raymond, born in 1910. William and Emma were married on May 8, 1895, by Reverend Schlee. William was the local photographer.

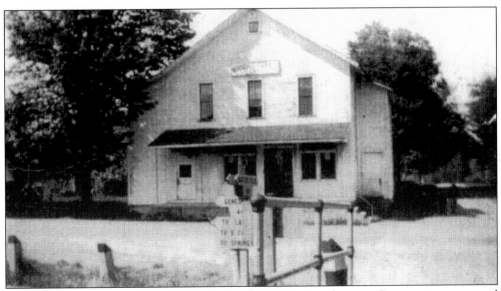

The Wyandale Grange was one of the centers for activities in the area. Community events and socials were held here.

This little boy is Ray Fattey. In the background are storage barns in Wyandale. This photograph was taken by Ray's father, W.G. Fattey.

This little girl is Florence Fattey. In the background, in a view looking southeast, is the "hamlet" of Wyandale at the crossroads of Genesee and Wyandale Roads. This picture was taken by Florence's father.

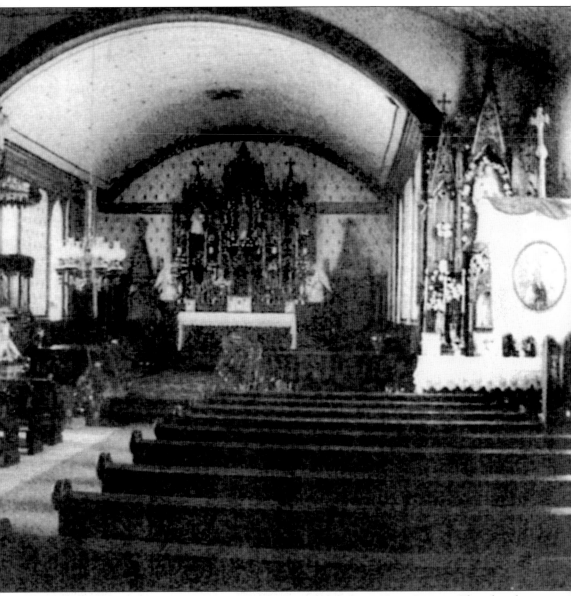

This is an early view of the interior of St. Mary's Church in New Oregon. The church celebrated its 110th anniversary in 1968. The first mass was celebrated on January 1, 1858, by a priest known only as Father Gerber. Most of the families are descendants of Germans from Alsace-Lorraine, who settled in New Oregon in the 1840s and 1850s.

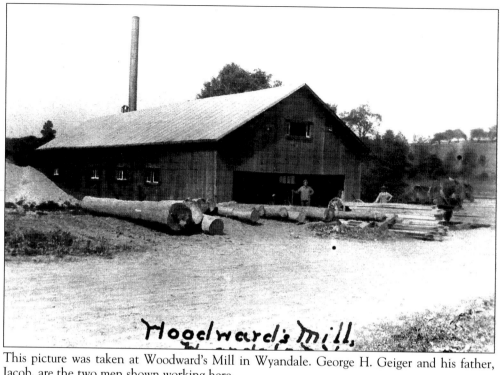

This picture was taken at Woodward's Mill in Wyandale. George H. Geiger and his father, Jacob, are the two men shown working here.

A family of Wyandale chickens is shown in this early view.

Four
EAST CONCORD

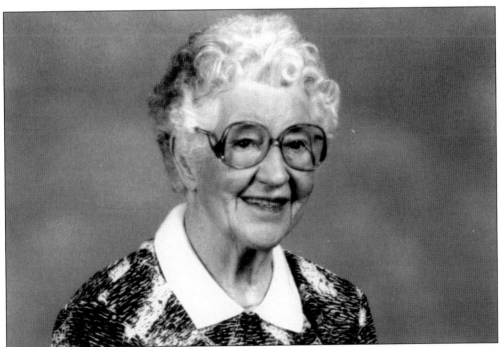

Evalyn Russell, at the age of 97, is "the Grand Lady of the Town of Concord." She was born Evalyn Treat on a farm in Waterville. In its early days, the farm was a stagecoach stop. Evalyn Russell was a wonderful teacher for many years and has always contributed much to preserving the history of the town.

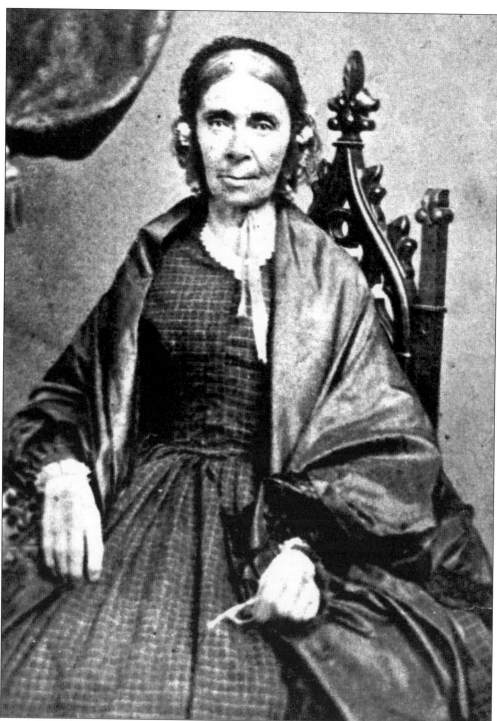

This is Sallie "Sarah" Griffith, wife of Archibald Griffith. They both came to this area from Rhode Island. Sallie died at the age of 81 in 1875. Both are buried in a small private cemetery maintained by Griffith Institute in Evergreen Cemetery, which is now known as the East Concord Cemetery.

Four neighborhood buddies and one American Flyer bike are shown in this photograph taken in May 1941. From left to right are Guy Scott, Charles Fisher, Donald Barthel, and Billy Pickett.

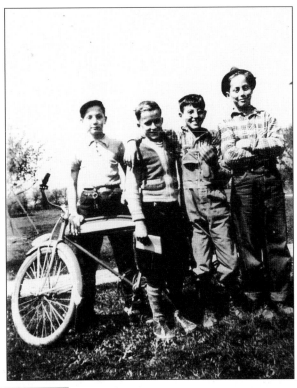

This young man is Charles Alson Shaw, who moved here as a young man from Michigan. He and his wife, Olive, lived on Allen Road in East Concord for more than 50 years.

This is the Harold Edington homestead, located at Buckwheat Corners, at the intersection of Route 240 and Allen Road. Edington was a milk inspector for the Dairyman's League, and his wife, the former Florence Cranston, was a schoolteacher and postmaster.

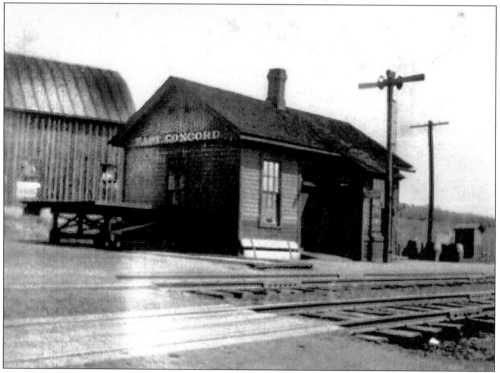

The East Concord depot is pictured here. Its dock is on the left. In the background is a barn, which could be Fred Domes's mill.

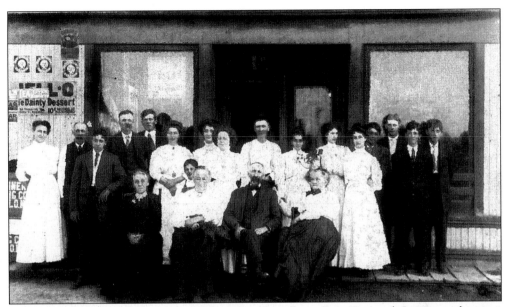

The Lumley store was located across the railroad tracks in East Concord. It was on the same side of the road as the depot. The only person who could be identified in the picture is the girl fifth from the right. This is Mae Lumley, who married Frank Barthel. Barthel had a blacksmith shop near the railroad.

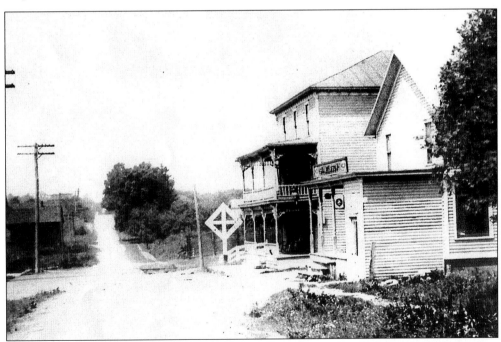

Genesee Road is shown in a view looking toward Sharp Street. On the left is the depot, and on the right is the old hotel and Shamel's Store. Two of the former owners of the hotel were Louis Smiler and a Mr. Miller. The hotel burned and the cause is still speculated. One story is that sparks from the train caused it. The other story is that Miller had a monkey that tipped over a lantern and caused the fire.

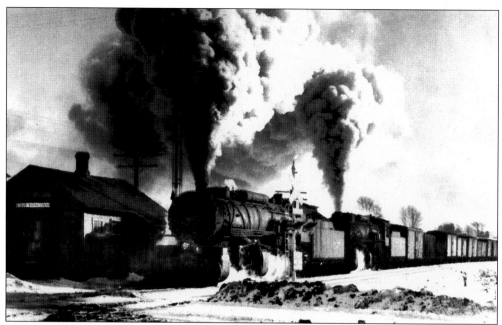

Here is the daily train huffing and puffing into the East Concord station. Some students took the train to Springville to go to school. The fare was 10¢ each way. The station also had an agent known as "the Merry Widow." This was because she was quite popular. Some of the boys found that their mother's kept them a lot busier when she was on duty.

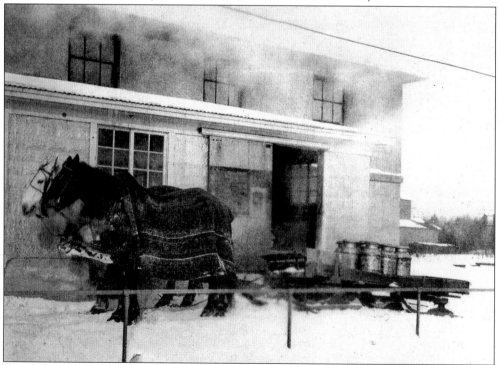

A team of horses brings a load of milk to the Condensery Plant. This is the building that was destined to become the first fire hall in East Concord.

This Home Bureau picnic was held in July 1952, probably at Emery Park. This was an annual event that the children looked forward to. On the slide are, from bottom to top, Bobby Mayerat, Pattie Barthel, Barbie Barthel, Danny Bickel, Linda Bickel, Jimmy Harrison, J. Harrison, Becky Mayerat, Kathy Hannon, unidentified, ? Hannon, Elizabeth Bump, and ? Bump.

When this picture was taken, 90-year-old Marion Smith was the special guest at a party celebrating her 75th year as a member of the East Concord Church.

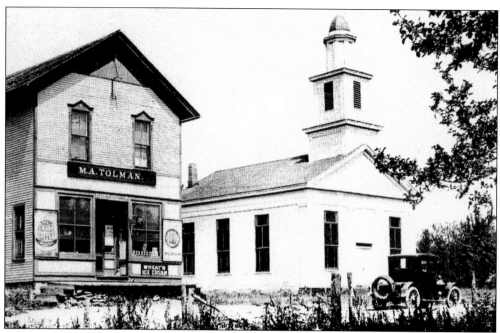

Shown are the Tolman store and the Baptist church. Mrs. Tolman and her sister Nellie Cranston lived next door to the store. It was always great fun to go to Ladies Aid at their house and talk to their parrot, which lived in a big cage on the sun porch.

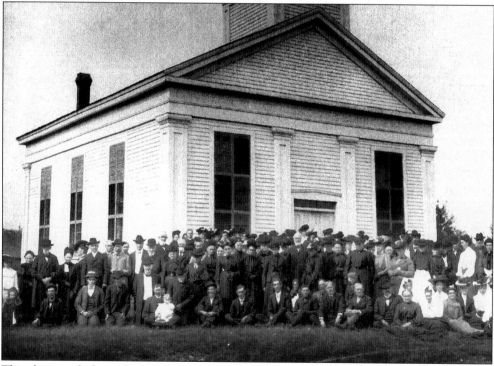

This photograph shows the East Concord Baptist Church folk celebrating their 50th anniversary. At this time, the church was the center of all social activity. The church was established in 1854.

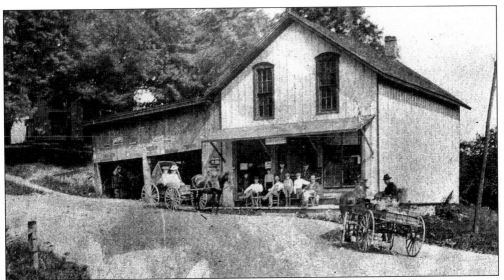

The Bement store, in the neighboring village of Glenwood, is shown in this photograph taken on July 1, 1904. Grace Barckley and her sister are in the buggy. The two boys standing in the middle of the doorway are Orlin Reynolds, in the white shirt, and Ernie Reynolds, his brother. The Ulrich house is in the background.

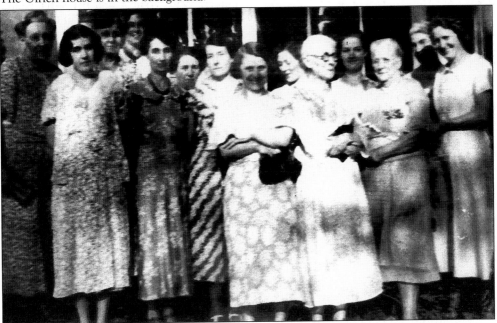

This East Concord Ladies Aid meeting was held at Felicie Flessiner's home on Vaughn Street in the 1930s or 1940s. They met once a month, and the ladies took turns entertaining, being in charge of the dinner, or just bringing a dish to pass. The dinner consisted of a donation that started out at 10¢ but went up to 25¢. The money was used for the meat for the next meeting, and anything left over was used for a worthy cause in the community. From left to right are Flora Vosburg, Genevive Miller, Nellie Cranston, Grace Andera, Mae Barthel, Mary Hare, Maude Fuller, Laura Domes, Dorothy Ash, Agnes Vosburg, Marion Smith, Effie Shaw, Grace Luce, and Felicie Flessiner. This picture was taken by Olive Shaw.

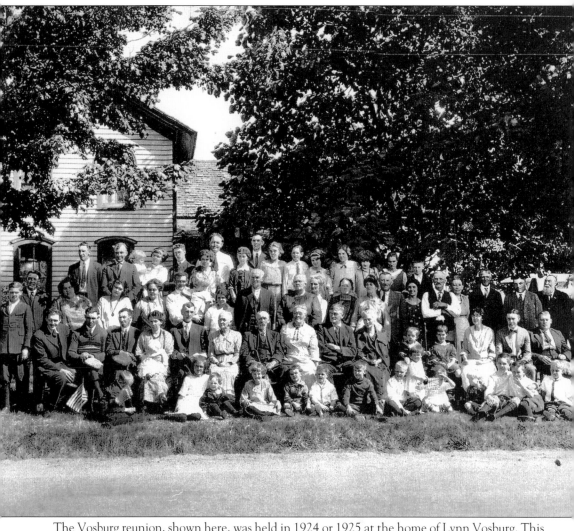

The Vosburg reunion, shown here, was held in 1924 or 1925 at the home of Lynn Vosburg. This house is located near the intersection of Allen Road and Route 240, formerly known as Buckwheat Corners. The former Annabelle Hare was able to identify all but one man in the picture.

Five

DISTRICT SCHOOLS

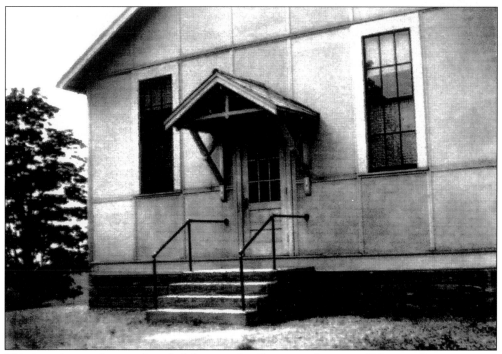

This is a picture of an unidentified district schoolhouse in the area of Mortons Corners.

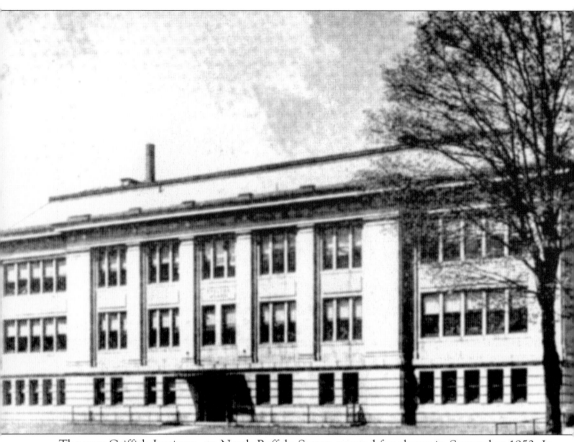

The new Griffith Institute, on North Buffalo Street, opened for classes in September 1952. It replaced this building (the previous Griffith Institute) on Academy Street. The new building could accommodate 600 students.

District No. 5 was located on Genesee Road at the corner of Transit Line and Middle Roads. This picture was taken in February 1933. During the winter months, the teacher lived across the street at the Wiser home.

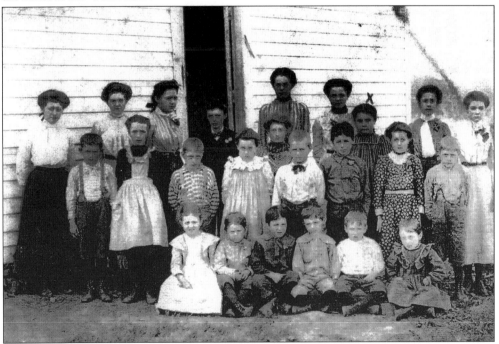

This school was located on Trevett Road on what is now the Wingeier property. The picture was taken in 1909. At a certain period in time, the school had inside plumbing consisting of chemical toilets, a rarity. The school closed in 1927 and moved to a new building across the street. Martha Emerling Wurtz, one of the girls in the picture, lived to be more than 100 years of age.

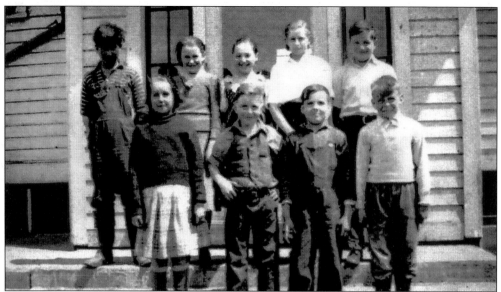

Alvin Kester was the teacher at District No. 6 in 1936. Located on Trevett Road near Wagner Road, this school opened in 1927 and closed in the early 1940s. There was no electricity in the area of the school. The drinking water was brought in from the old school across the road. The children in the picture are identified as Theodora Zyudzik, Harold Schmitz, Paul Emerling, George Milks, Gerard Schunk, Marjorie Milks, Mary Schunk, Gloria Herren, and Carl Blesy.

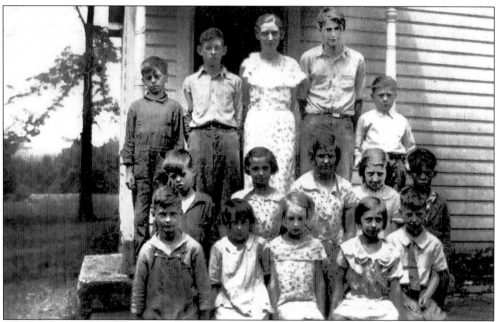

This picture of District No. 7 was taken on June 15, 1934, at the school on Concord Road near Spaulding Road. Included in the photograph are Herbert Belscher, Marge Gamel, Alberta Hazen, Loretta Darzewski, Ken Trevett, Ray Darzewski, Margaret Belscher, Martha Belscher, Elinor Harpon, Arthur Roberts, Stanley Darzewski, Elinor Lotter, Martin Belscher, and Leonard Hayson.

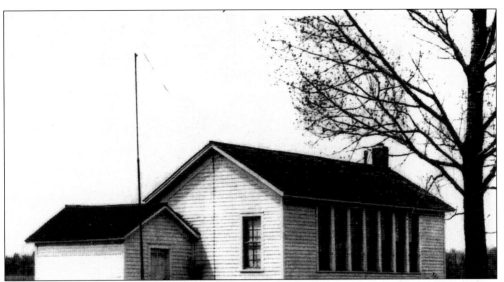

This is Springville School District No. 8 at Route 39 near Trevett Road. The picture was taken on April 20, 1949. The poplar tree was still standing in 2001.

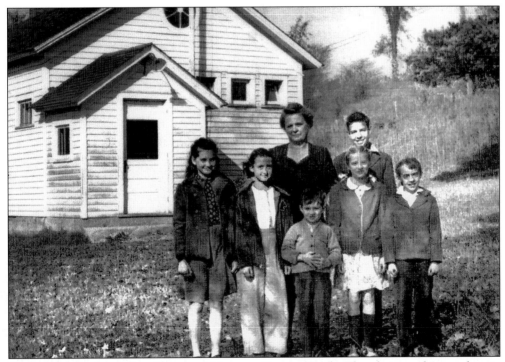

This school was located at Grote and Mortons Corners Roads. The photograph was taken in 1948, and the school was closed in 1950. The teacher is Shirley Felton. The children are identified as Marlene Chinchen, Idamae Really, Henry Cieszynski, Dorothy Klahn, Norma Klahn, and Henry Johnson.

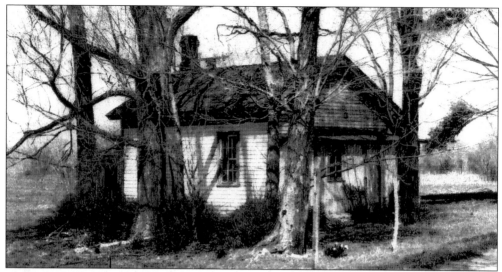

The Zoar Valley School, which was torn down in the late 1940s, was located west of the Rifle Range. It was known as Concord District No. 12.

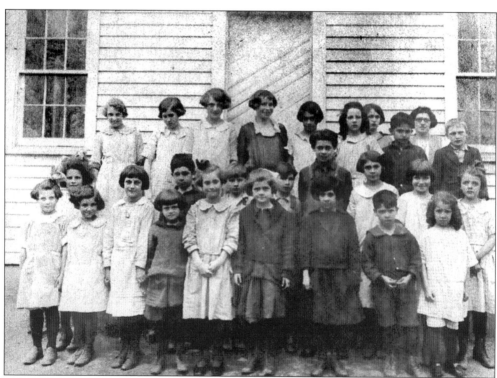

This is the original schoolhouse of District No. 13 in East Concord in 1901 or 1902, located at the five corners. Grace Barckley was the teacher when this picture was taken. The building was later moved across the street on Allen Road and became the home of Eli and Flora Vosburg.

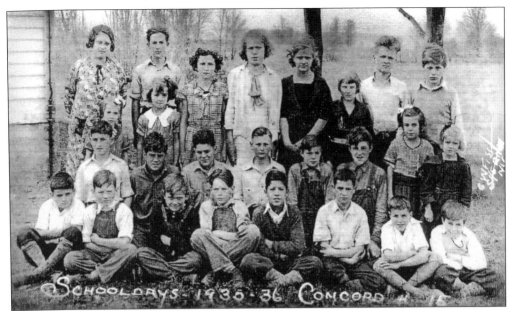

This is Feddick Road School District No. 15. Included in the photograph are Clifford Enser, Albert Spors, Bernard Enser, Frank Ferro, Louis Fabian, David Maitland, Richard Holcher, William Bartoski, Julius Meyer, Donald Meyer, Jane Holcher, Vivian Turton, teacher Mildred Wohlhueter, Mary Jane Schmitt, Betty Portman, Mark Enser, Lollie Golabek, Angeline Stackowitz, Marie Spors, Irene Bartocik, and Anthony Golabek.

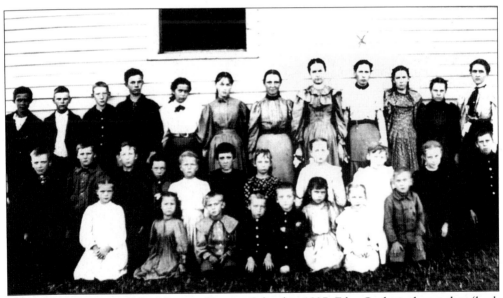

This is a group picture of the Mortons Corners School in 1897. Edna Scoby is the teacher (back row, far right). The others are identified as Lora Rogers, Leska Blakely, Harley Sucher, Charles Zeffer, Glenn Curtis, Leska Geiger, Mabel Moore, Fred Franz, Herman Franz, Claire Markham, Howard Curtis, Lowell Blakely, Lottie Rogers, John Heath, Nellie Curtis, Hattie Moore, Etta Hornburger, Joe Casline, John Rogers, John Franz, Ray Keazer, Gurney Schue, Alma Rogers, Hazel Blakely, Anna Rogers, Mary Schue, Madge Blakely, Jennie Briggs, and Nora Cosline.

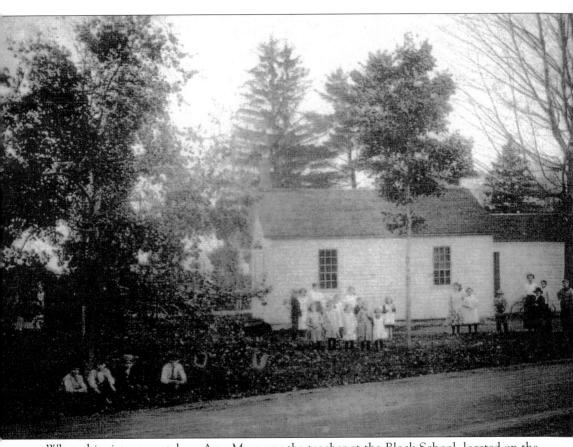

When this picture was taken, Amy Mayo was the teacher at the Block School, located on the Springville-Boston Road at Middle Road near Fairview Cemetery. From 1943 through 1944, this school was moved in three pieces by Higgins Haulers to Abbott Road near Newton Road.